# Watch Spotting | The Collectors

# Watch Spotting | The Collectors

Rhonda Riche

ACC ART BOOKS

Introduction
06

Index
156

Picture Credits
159

*The Collectors*

David and Victoria Beckham
08

Orlando Bloom
16

Marlon Brando
20

Catherine Deneuve
24

Diana, Princess of Wales
30

Robert Downey Jr
34

Roger Federer
38

Ryan Gosling
44

Lewis Hamilton
48

Kevin Hart
54

LeBron James
60

Jay-Z
66

Elton John
72

John Mayer
76

Steve McQueen
82

Lionel Messi
86

Paul Newman
90

Brad Pitt
96

Rihanna
100

Cristiano Ronaldo
104

Arnold Schwarzenegger
108

Ed Sheeran
114

Sylvester Stallone
120

Taylor Swift
124

Tyler, The Creator
128

Andy Warhol
132

Pharrell Williams
138

Serena Williams
144

Michelle Yeoh
150

# Introduction

What is watch spotting? Basically, it's not much different to trainspotting or bird watching or any activity that involves enthusiasts noting the location and distinctive characteristics of a particular object or animal. It's the act of catching a celebrity, politician or potentate wearing a particular timepiece in the wild.

The internet supercharged the watch-spotting phenomenon. Photographs of actors on the red carpet or athletes entering a stadium led to speculation about what watches they were wearing. Suddenly, there were hundreds of Instagram accounts dedicated to identifying luxury watches.

If you are a watch enthusiast, you are no doubt captivated by wondering what the people around you are collecting (and why). Many stars, like Brad Pitt for example, are also certified watch nerds. Pitt has an extensive personal collection of mostly vintage mechanical timepieces, but his hobby also informs what he wears on screen. For the movie *Moneyball* (2011), the prop master presented Pitt with a couple of watches to help him get into character, borrowing a crew member's TAG Heuer Kirium WL1113 as one of the options. Pitt chose this as his preferred watch and three 'doubles' were then sourced for good measure.

For other people, watches are status symbols. Getting your first luxury watch has long been a way to say that you've made it. On the 1999 track 'Nas Is Like', the rapper Nas described switching up to a Rolex from a Seiko. Travel further back in time and you have screen legends like Marlon Brando or Paul Newman being presented with Rolexes to commemorate milestones in their professional or personal journeys.

For many of the collectors in this book, Rolex is merely the gateway drug. Brando's collection probably topped out at about

10 watches – which would have been considered a lot in his time. With the excesses of our modern society, however, numbers have risen. Ed Sheeran has upwards of 18.

While many athletes adore Audemars Piguet, artists and fashionistas are into Cartier. And everybody loves Patek Philippe. For athletes, becoming an ambassador for a high-end horological house is part of the gameplan. Yes, some jump from brand to brand chasing the highest pay cheque, but for others, what starts out as flexing often crosses over into a deep fascination for time telling. John Mayer, for example, has written about watches for the online platform *Hodinkee*. Actress Michelle Yeoh is both a collector of and a collaborator with Richard Mille.

Investigating a celebrity's watch collection creates a timeline of how their tastes and interests change along with their fortunes. In many cases, it also makes the famous a little more relatable – especially if you discover that you both share a fascination with vintage watches or chronographs, for example. Every timepiece tells a story, after all.

The blueprint for Jay-Z's rise to the top can be traced from Casios to Patek Philippes. Diana Spencer's journey from the palace to becoming the people's princess is almost the reverse: from being spotted wearing Patek at polo matches to wearing a simpler Cartier while advocating for victims of landmines (okay, Cartier isn't quite a G-Shock, but you get the idea). Watches have a lot to say about the people wearing them, whether they are emo kids in New York or super rich socialites from Singapore.

As part of the bigger picture, female collectors like Rihanna are influencing a younger generation of enthusiasts by displaying their diverse collection in inventive ways, such as wearing a watch as a choker or an anklet. Rihanna has made brands like Franck Muller popular again and promoted timepieces of all sizes to both boys and girls.

Timepieces are also something more meaningful than most of the things we wear or buy, which is why fans will line up for days to get their hands on a MoonSwatch or put their names on years-long waiting lists in the hope of getting their hands on a Rolex Daytona. For dedicated watch spotters, timepieces are less a commodity, and more a way to build a community among fans, brands and collectors.

Even when the watch on a star's wrist is a one-of-a-kind, million-dollar mechanism, this shared passion can strike up a connection with people (online and in real life) that you might not have been able to make in any other context. And once you join this horological congregation, you'll learn more about the craft and technology that goes into the most iconic timepieces. It might be the most entertaining rabbit hole you've ever fallen down.

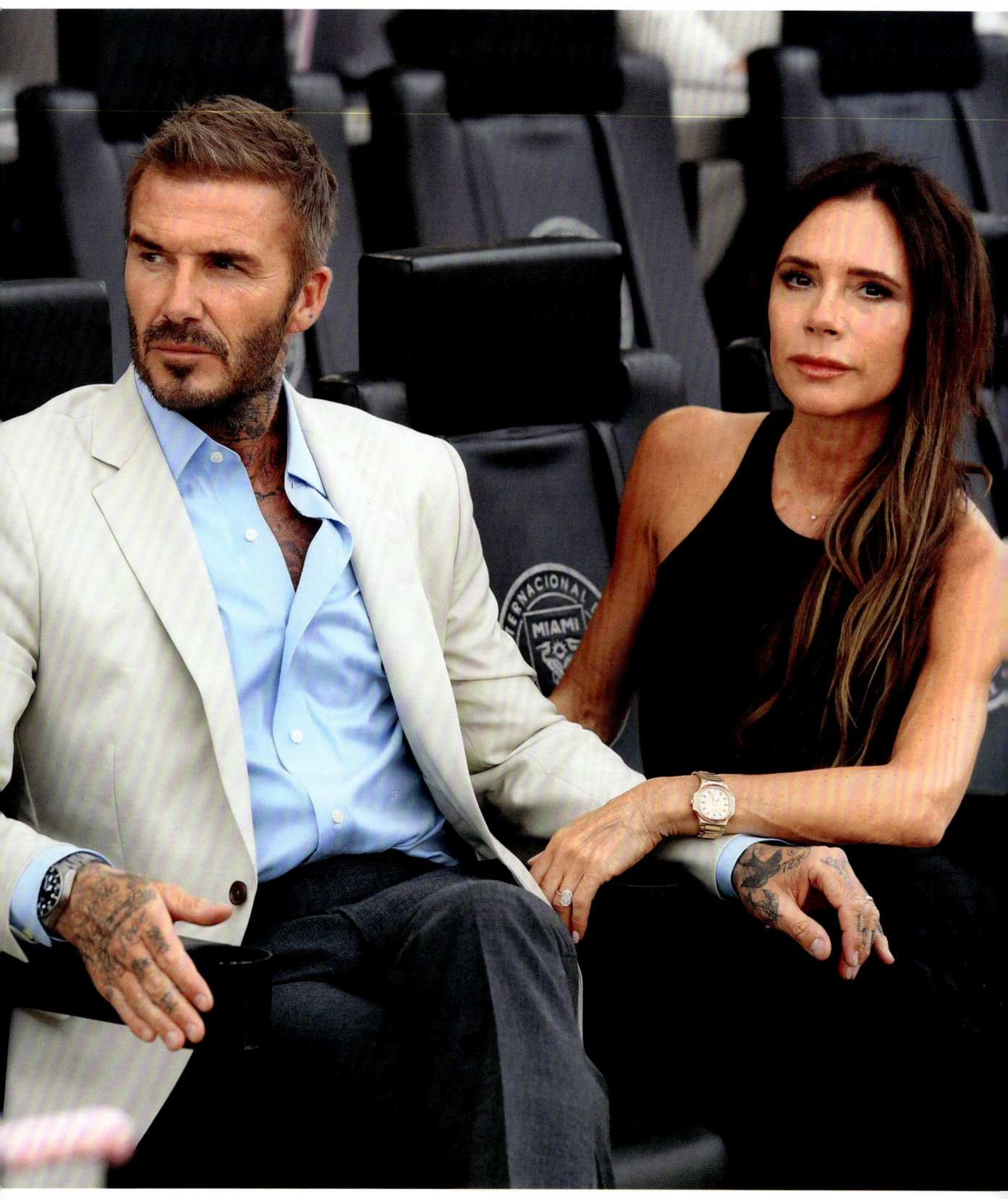

# David and Victoria Beckham

"As soon as we got money, it was like, 'I want to buy a nice watch'." —David Beckham

Opposite. David and Victoria Beckham together in the stands at the Leagues Cup 2023 Match between Inter-Miami CF and Atlanta United in July 2023.

## MAKING A PITCH

David Beckham is one of the most beloved footballers of all time. As the first English player to win league titles in four different countries – England, Spain, the United States and France – his fame as a player and later a team owner is unparalleled internationally.

Largely based on his good looks and blend of casual cool, DB7 (as Beckham is sometimes known) is also considered a modern style icon, which is why Tudor signed him as a brand ambassador in 2017. But the biggest asset the football legend brought to the brand is his authentic passion for horological history.

While contractual obligations now keep tight reins on Beckham's impressive watch collection, pre-Tudor the sports legend was frequently photographed wearing some of the most beautiful examples of haute horology, including a Patek Philippe Grand Complications Celestial. This choice of watch feels very apt for a celebrity whose place in pop culture lives in the intersection between natural athletic ability, hard work and marketing savvy.

The Celestial's dial displays hours and minutes of mean solar time, a sky chart and the phases and orbit of the Moon. To do this, the face is formed by layering different colours of metalised sapphire crystal. The black base level depicts the heavens (as seen from Geneva) and the Moon's phases. While the transparent sapphire-crystal disks depict the sky chart and the Milky Way.

Not only is the Celestial stunning to look at, but it's also even more luxurious on the wrist. Beckham's model has a 44mm case made of platinum. The hand-stitched, navy-blue strap is made of alligator with a platinum fold-over clasp. It's posher than Victoria Beckham! But he has also used his association with Tudor and this timepiece as a platform to promote his goals as a UNICEF Goodwill Ambassador dedicated to the health and education of children in Africa.

This page. When David Beckham dreamed up Inter-Miami CF, pink was incorporated into the team's aesthetic. Tudor is the official timekeeper of the Inter Miami CF and the Tudor Black Bay Chrono 'Pink' sums up the team's spirit. Image courtesy of Tudor.

Opposite. David Beckham serving style at Wimbledon in 2022 wearing a Tudor Black Bay Pro.

Beckham is a total package with a fervent fan base and it's this aspect of his celebrity status that allows fans to square his appreciation for the Patek level of luxury with his association with the more accessible Tudor brand. Most recently he's been seen sporting the Tudor Black Bay Chrono Pink on TV shows such as *Hot Ones*, where he promoted the Netflix documentary *Beckham*, while eating extremely spicy chicken wings.

Beckham is also a co-owner and the president of Inter Miami, and the rose-coloured dial of this 41mm-wide Chrono reflects the livery of the team. This vintage-style tool watch also embodies Beck's personal style: who better to popularise a pink watch than the man who invented the faux-hawk hairstyle?

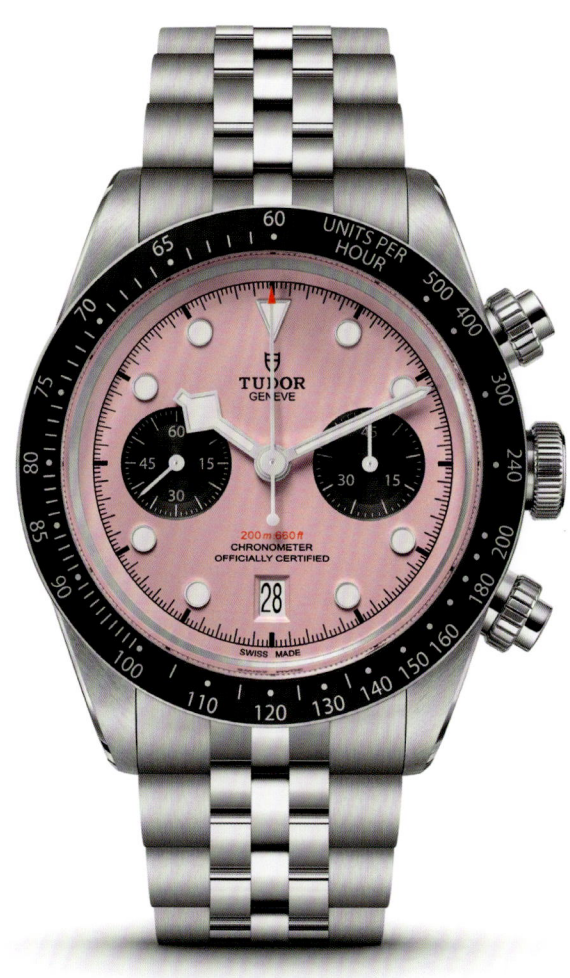

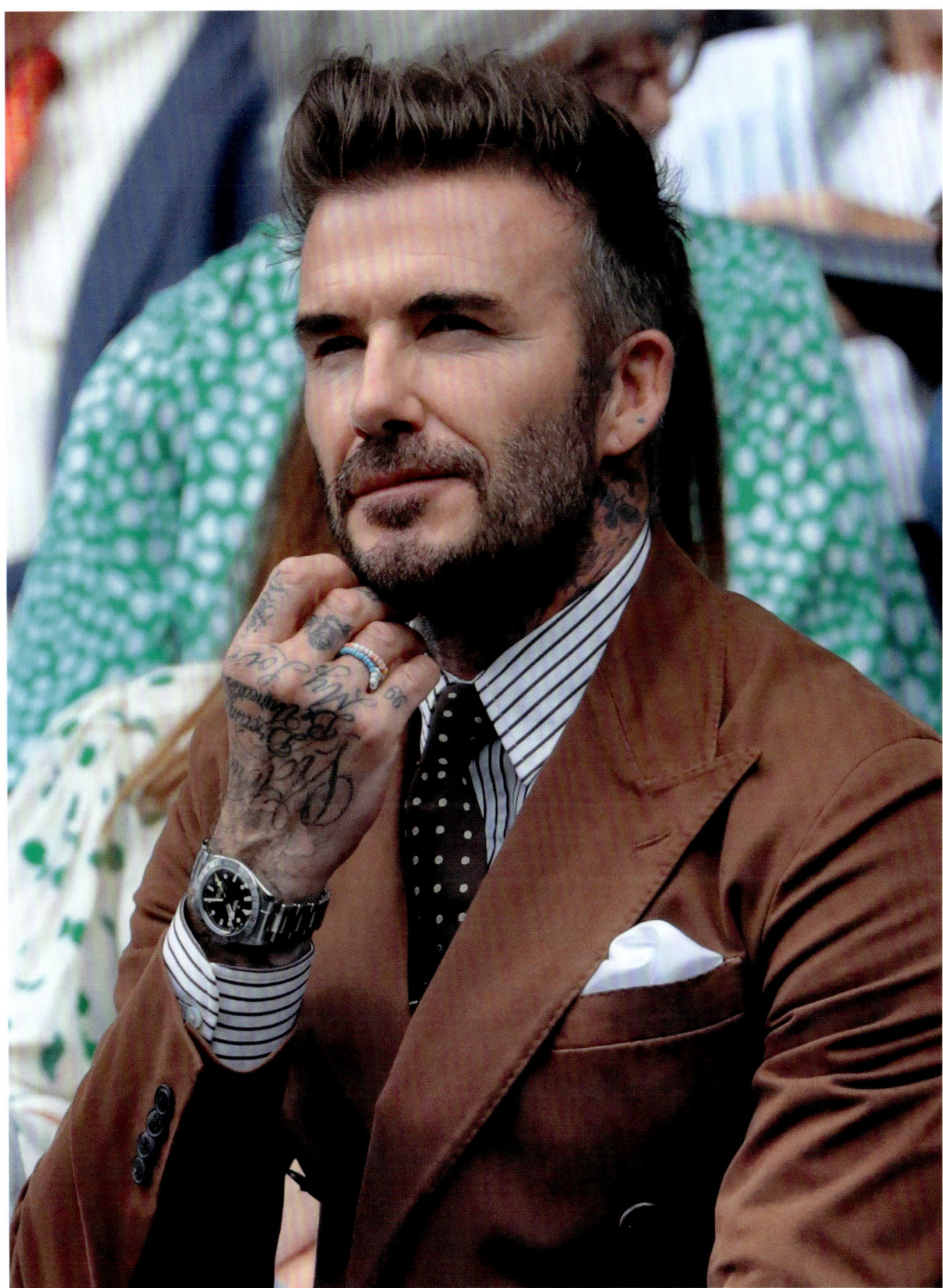

This page. David and Victoria wore 18K yellow-gold Rolex Yacht-Masters like this 1992 model to announce their 1998 engagement. Image © Rolex/Jean Daniel-Meyer.

Opposite. Victoria Beckham sports a Rolex Everose gold Cosmograph Daytona at the Hollywood Walk of Fame presentation in LA for former Spice Girls manager Simon Fuller.

But David Beckham hasn't embarked on his watch collecting journey alone.

Anyone born in the 20th century is aware of the cultural impact of Posh and Becks on pop culture. Victoria was a member of the Spice Girls – the best-selling British pop act since The Beatles and the quintet that popularised 'girl power'. The late '90s was also the golden era of David Beckham, a footballer so famous that his signature move served as the title of the hit movie *Bend It Like Beckham* (2002).

Keeping their budding romance hidden from the paparazzi was a bit of a challenge. The press finally figured it out when David and Victoria were spotted wearing matching his and hers Cartier Tank Française watches.

In keeping with the horological theme of their romance, the couple announced their upcoming nuptials with engagement watches instead of rings. In this case, a pair of Rolex Yacht-Masters.

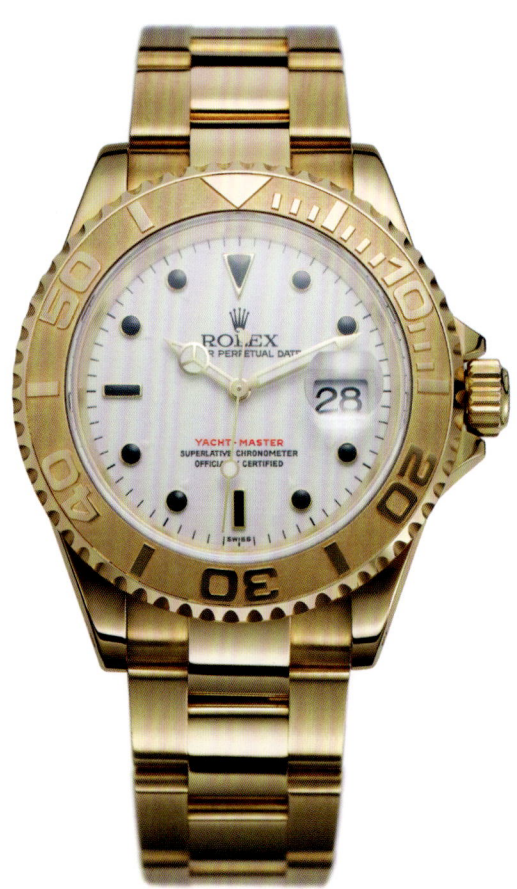

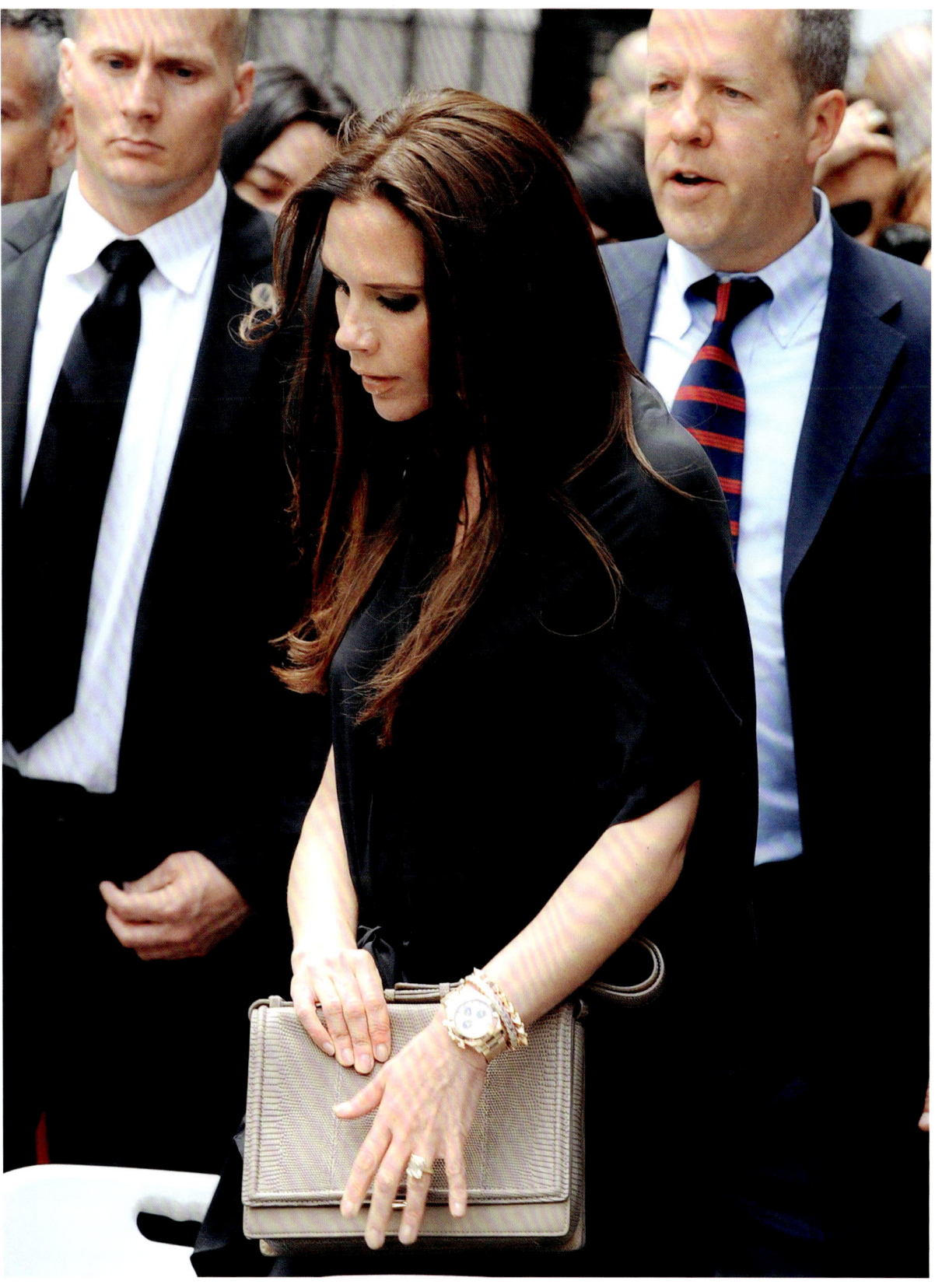

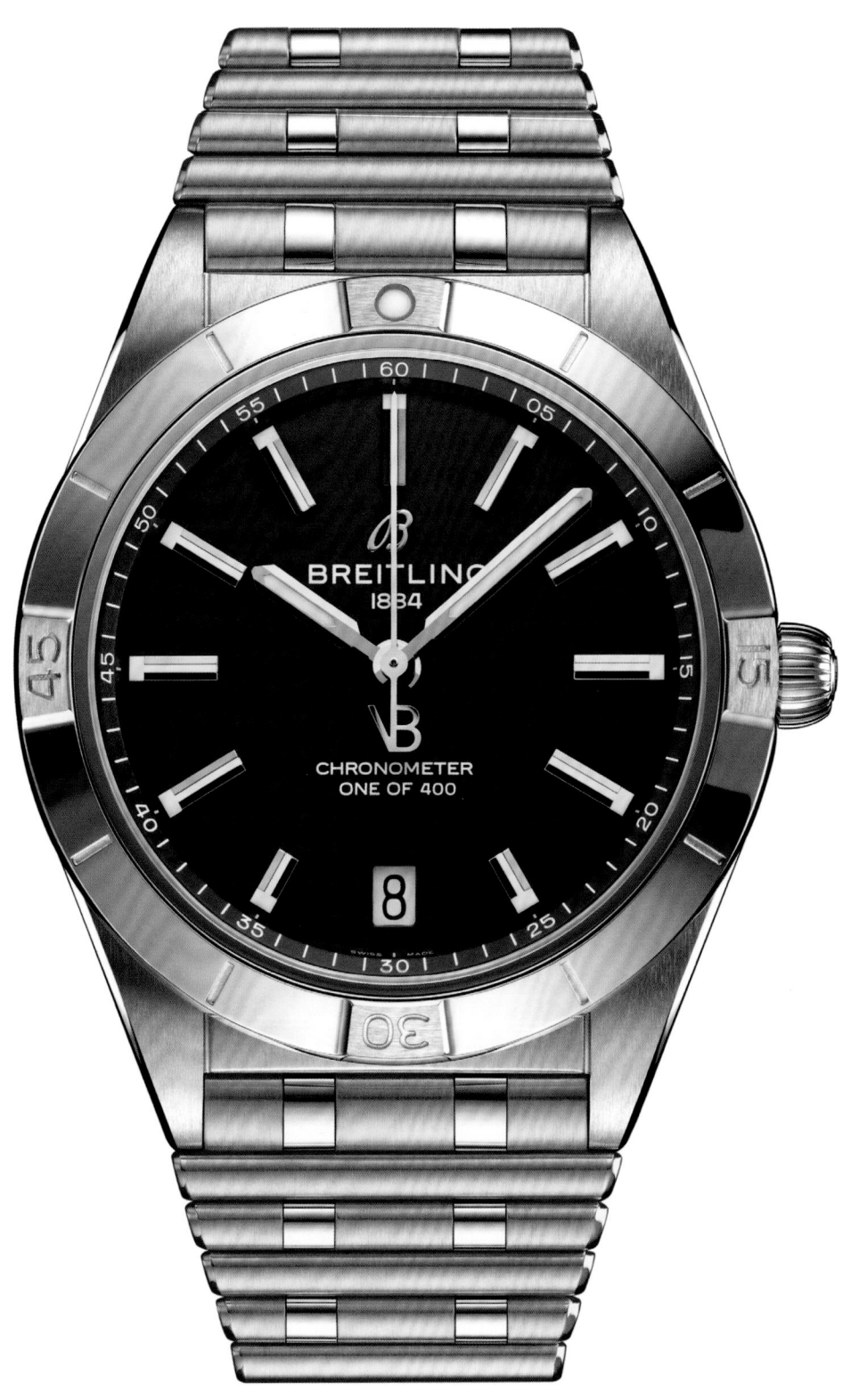

After the Spice Girls split up. Victoria set out on a second career as a fashion designer. In 2011 and 2014, she was awarded Brand of the Year at the British Fashion Awards. And in 2019, she launched Victoria Beckham Beauty.

While watches are a part of Posh and Becks's love language, Victoria is very much her own woman when it comes to her taste in timepieces. She helped popularise women wearing 'man-sized' Rolexes in the aughties, and she has been frequently photographed wearing a 40mm pink-gold Rolex Daytona.

Victoria Beckham's keen eye for horological design details has also informed her fashion aesthetics. Her winter 2023 collection included a pair of gold-plated brass earrings that have a resemblance to the links of the Oyster bracelet found on her 1970s Datejust with a green enamel 'Stella' dial.

When it comes to watches, Posh can also be sporty. Fans of her Instagram account have spotted her wearing a stainless-steel, blue-dialled Nautilus reference 7118/1A-001 in her candid selfies.

All this horological history came in handy when, in 2024, Victoria partnered with Breitling on a limited-edition series for its Chronomat Automatic 36 collection. This series featured face colours that aligned with the British designer's spring/summer 2024 collection. The Chronomat is one of the brand's most popular models and is powered by a super-precise self-winding movement, which, unlike a quartz watch, doesn't need a battery to function. Not only that, but the time-and-date model features a sporty but elegant bracelet with options of bold blue, green or more subdued champagne dials.

According to the brand's CEO Georges Kern, the collaboration with Beckham has helped Breitling tap "into the world of fashion, something not every watch brand could do. Her relevance within the fashion industry enables us to speak to fashion-savvy women, while simultaneously reaching a broader female audience".

This page. Victoria Beckham likes big watches and is frequently seen wearing a Rolex Everose gold Cosmograph Daytona like this model. Image © Rolex.

Opposite. Posh's cool collaboration with Breitling – the Chronomat Automatic 36 Victoria Beckham. Image courtesy of Breitling.

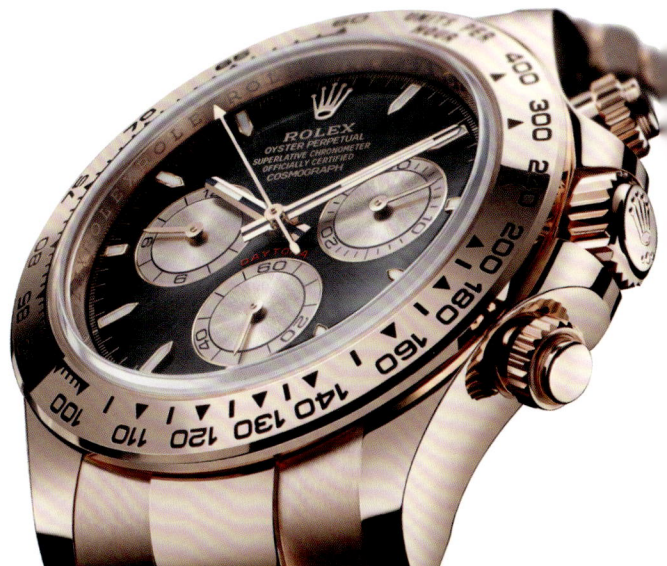

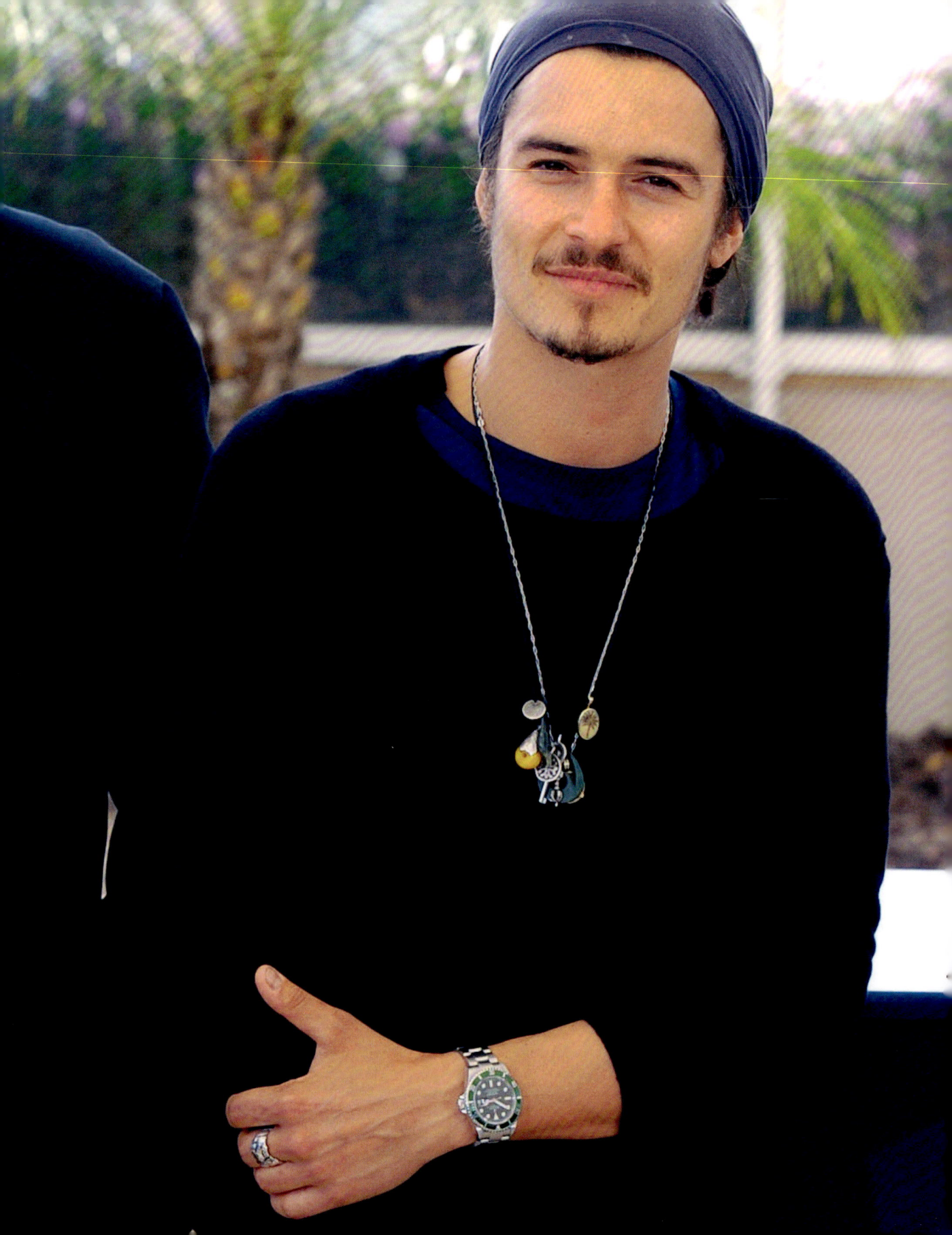

# Orlando Bloom

"The best way to look stylish on a budget is to try second-hand, bargain hunting, and vintage."
—Orlando Bloom

**WATCH OUT**

Opposite. Orlando Bloom in 2004 wearing his vintage green-bezelled Rolex Explorer Ref. 1016 'Kermit' Submariner.

What drives a person to collect watches in the first place? For some it's the thrill of the chase – researching a specific brand or model of watch and then going to any lengths necessary to get their hands on it. The adrenaline rush of finding a dream piece is addictive.

English actor Orlando Bloom is one such hunter, best known for appearing in thrilling adventure films, such as *The Lord of the Rings* trilogy (2001–2003) and *Pirates of the Caribbean* film series of the aughties. In his private life, he has been investing in watches since he started making movies, usually buying one to commemorate each project. Among watch spotters, he is noted for his astute collection of rare Rolexes, most attained by research, networking and globetrotting – things that an actor's life is well suited for.

He knows what he wants, and he knows how to get it. His collection includes a green-bezelled Rolex Explorer Ref. 1016, 'Kermit' Submariner, a GMT-Master 'Pepsi' Ref. 1675, an Explorer II Ref. 1655, a Submariner Ref. 6538 'James Bond', and a first edition Milgauss Ref. 6543.

An upside of Bloom's networking and knowledge base is that he has also discovered newer timepieces. While British watchmakers Bremont aren't as well known as Rolex, Bloom has an emotional attachment to the brand and owns multiple pieces. Founded in 2002 by brothers and aviation fans Giles and Nick English, the British brand appeals to Bloom's English sensibilities. One of his favourite examples is especially meaningful: the P-51 Limited Edition which features original parts from the legendary 1944 Mustang aircraft P-51K-10 from the Second World War. Flown by RAF pilots in the Pacific, it was also known as 'Fragile but Agile'.

Opposite. Front and back of Bloom's Bremont P-51, a limited-edition chronograph chronometer containing original parts from the famous 1944 Mustang World War II aircraft P-51K-10. Images courtesy of Bremont.

One of the down sides of being a celebrity watch collector is that your precious babies are on display for the whole world to see. And sometimes that can draw unwanted attention from nefarious types. From 2008 to 2009, an outfit known as the Bling Ring (a group of celebrity-obsessed Los Angeles teens) targeted A-listers like Paris Hilton, Lindsay Lohan and Bloom by tracking the stars on social media and using that info to break and enter their homes. All in all, the thieves nabbed over $3 million in stolen cash and personal items. As far as true-crime stories go, it was particularly salacious. It was even turned into a 2013 movie by Sofia Coppola called *The Bling Ring*.

Coppola's film focused on the criminals, but the story of how Bloom got his watches back is just as entertaining. In an appearance on the *Late Late Show* in 2023, Bloom recounted the tale, admitting to the show's host James Corden that he didn't keep his timepieces in a safe. "It didn't even occur to me at that point in my life. And they took some very expensive watches."

The stolen watches included pieces from IWC and Bremont, as well as the aforementioned Rolexes. Luckily, Bloom was able to use his watch-hunting skills to get some of his timepieces back. "Three months after the robbery, I got a phone call from a guy who I'd actually bought some of the watches from saying, 'I think your watches are surfacing,'" Bloom said. "So, I go and meet the guy, and he goes, 'I think you can probably get them back if you wanna'."

The buyer gave Bloom the contact information of the man attempting to sell the watches, which is when the actor went into spy mode. After getting some advice from a private detective, Bloom wired himself up with a microphone and drove down to the seller's pawn shop to pay him a 'friendly' visit. As Bloom recounted, the store owner was definitely "freaked out" to see the star in person. "I was like, 'Listen, no police, but I'd like to get my watches back.' He's like, 'I've got to go around. I've got to rough some people up.' There's this whole story… I said, 'Well, let's go! Let's go! I'll rough some people up!'"

The man later returned half of the watches Bloom had had stolen from him. Apparently, the actor's collection was so rarified that the fence had had trouble offloading them.

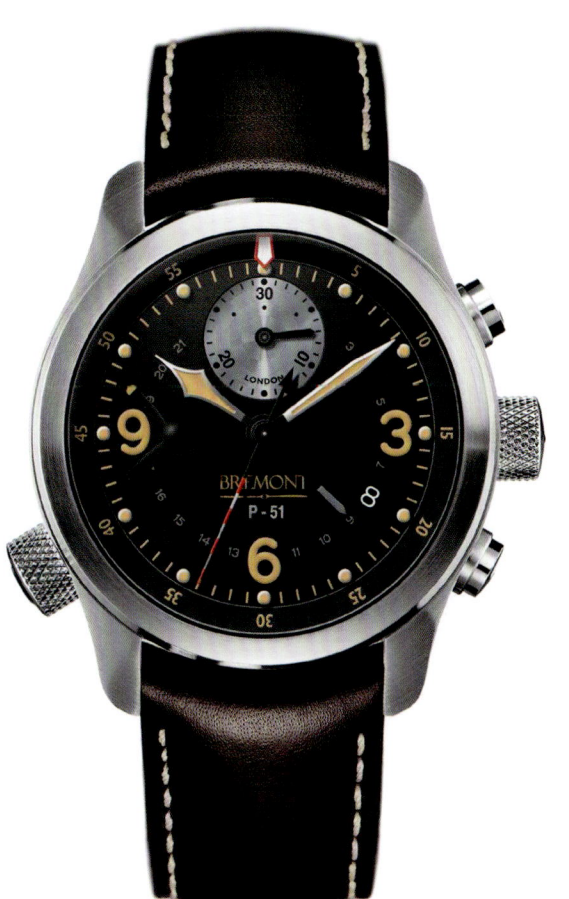
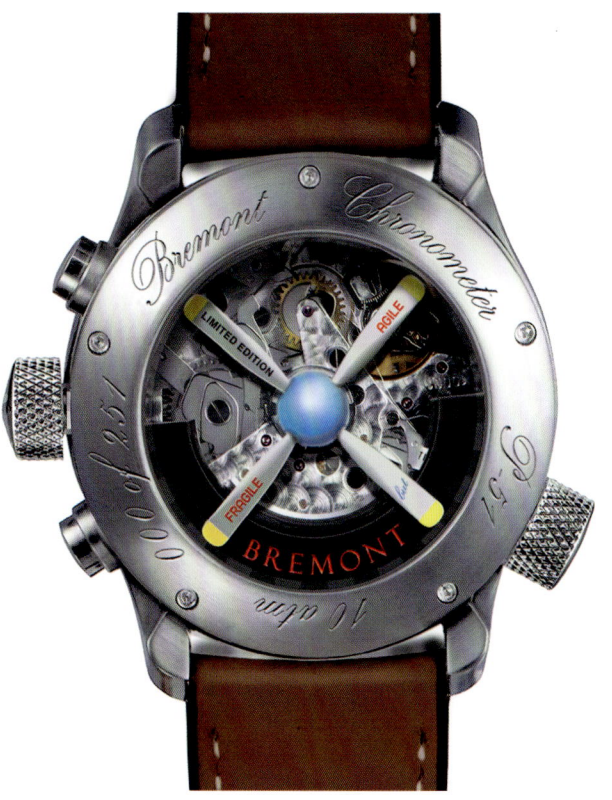

# Marlon Brando

"In a close-up, the audience is only inches away, and your face becomes the stage." —Marlon Brando

**SCREEN TIME**

Opposite. Marlon Brando on the set of *Apocalypse Now* wearing his personal Rolex GMT Master.

It isn't always easy to separate American actor Marlon Brando from his most celebrated film roles, and the same goes for his watch collection. Much has been written about the Rolex GMT Master he wore in the 1979 film *Apocalypse Now*. This busted up (it is famously missing its bezel) Rollie first came up for auction in 2019 where it sold for US$1,950,200 (£1.5 million). Colonel Kurtz's watch came under the hammer again in 2023, this time selling for just over US$5 million (£4 million). And then there's Brando's personal, stainless-steel, 31mm 1973 Rolex Datejust, the watch that he was given after he won an Oscar for his role as Don Vito Corleone in *The Godfather* (1972). He had the back of the watch engraved with 'Vito's' and the initials 'MB', a reference to his cinematic character.

There are many opportunities to see Brando's watch collection onscreen. In the 1964 film *Bedtime Story*, the actor wears his own Omega Seamaster 300. Brando also owned a solid 18K yellow-gold Rolex Datejust with a five-link Jubilee bracelet, which he wore in *Last Tango in Paris* (1972).

The most personal of Brando's timepieces, however, is housed in the Heritage Private Collection of Vacheron Constantin archives in Geneva. The small, yellow-gold mid-century Ref. 4877 model is inscribed 'To Marlon Love Zsa Zsa June 24, 1954' – Zsa Zsa being the Hungarian-born glamour queen Zsa Zsa Gabor. This watch acts as a tiny time capsule of old Hollywood glamour, Gabor and her sisters being among the first celebrities to be famous for being famous – the Kardashians of their day. The story is that Zsa Zsa gifted Brando this elegant VC in recognition of his 1955 Oscar Best Actor nomination for *On the Waterfront*. It's said he wore the

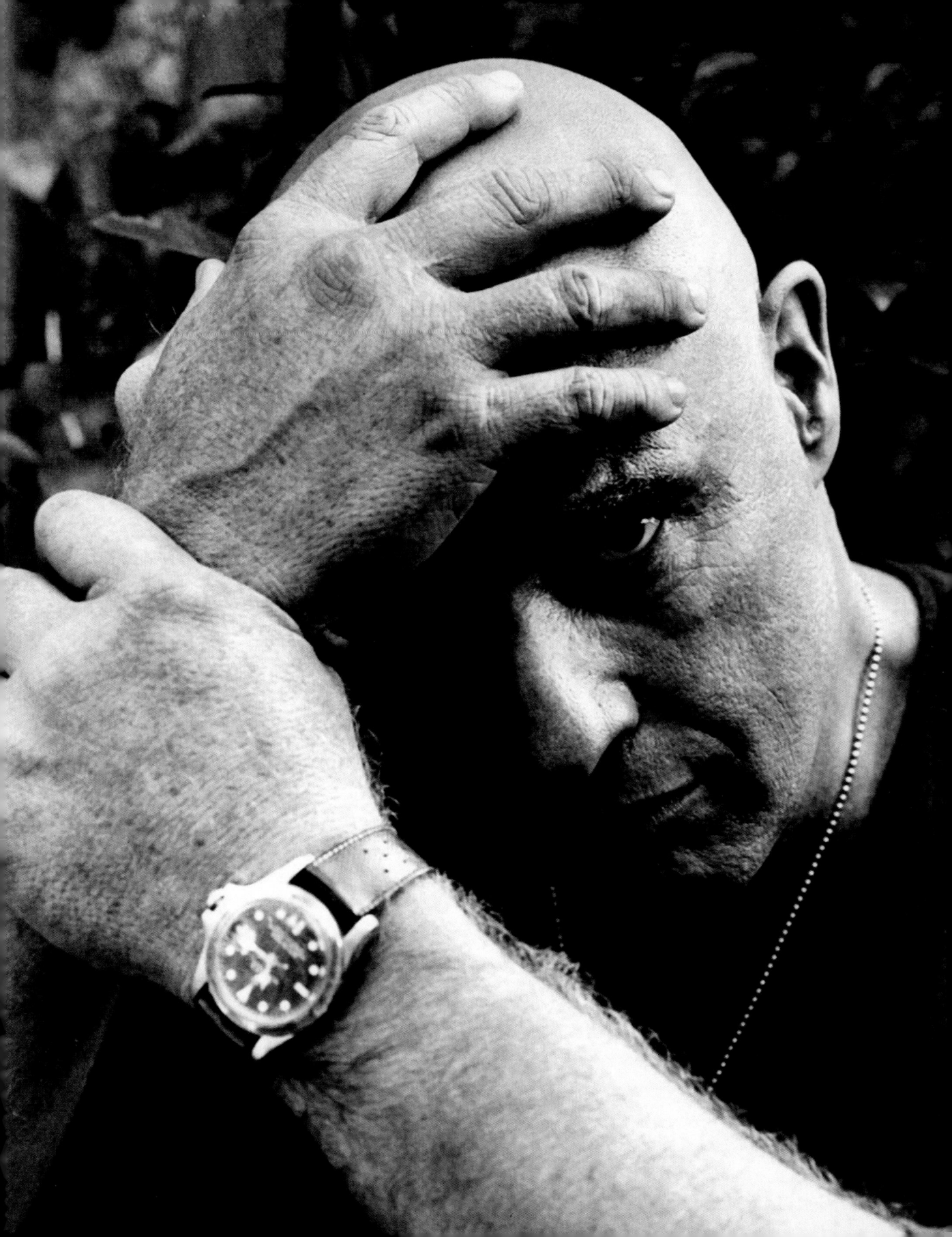

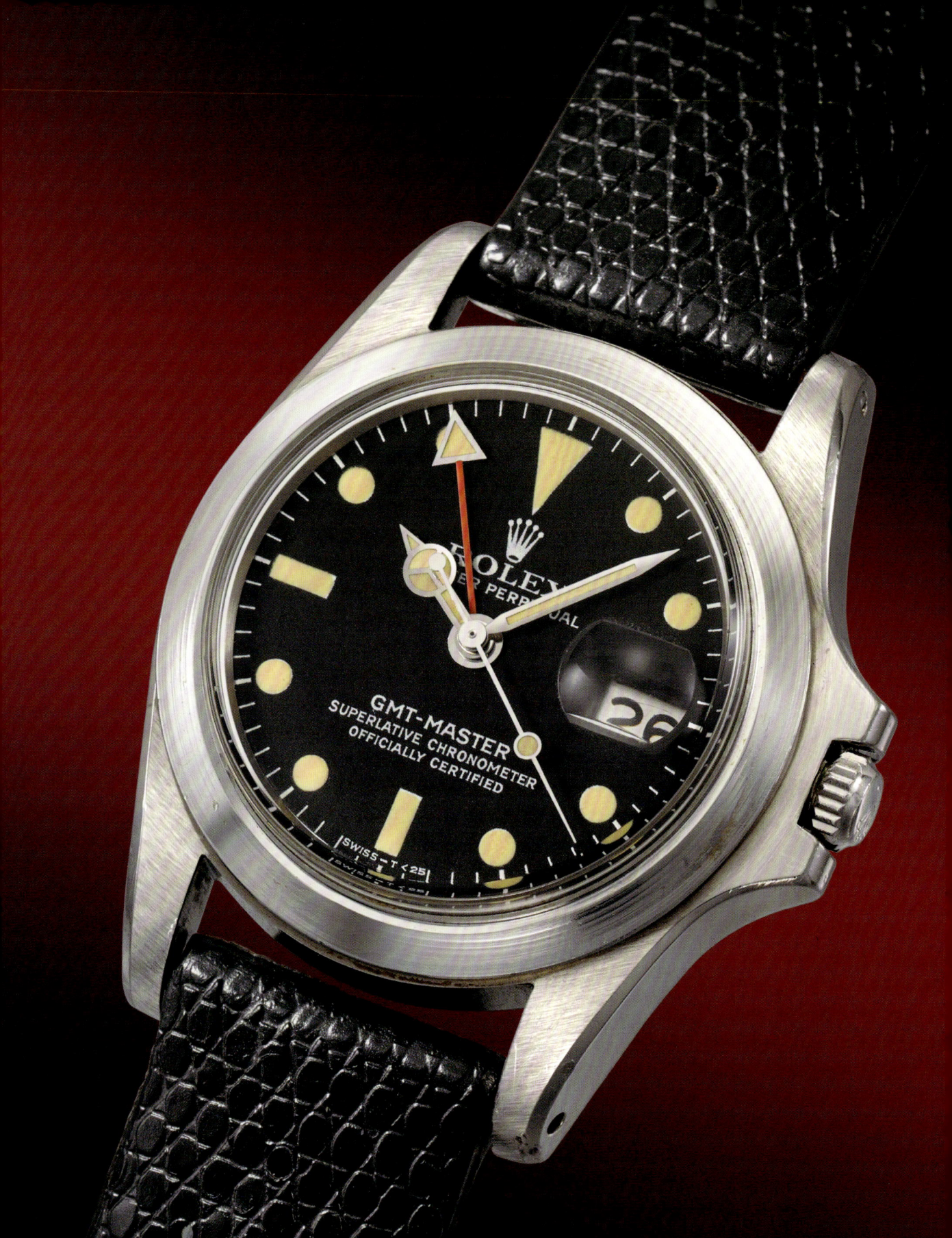

This page. Marlon Brando on the set of *Apocalypse Now* wearing his personal Rolex GMT Master.

Opposite. The same movie-worn watch was part of Christie's 'Passion for Time – An Important Private Collection of Watches and Timepieces' auction in November 2023 where it sold for CHF 4,582,500. Courtesy CHRISTIE'S IMAGES LTD. 2025.

timepiece to receive the award (though having looked through all kinds of footage of the ceremony, if that watch was on his wrist, it disappeared under the cuffs of his tux).

What really makes this watch exciting, though, is its distinct 1950s signatures. Specifically, the small seconds sub dial, the undulating hand-crafted *guilloché* dial, and the polished lapidated lugs. While small, this timepiece is powerful: it has a 17 jewel Cal. 1001 movement with a straight-line lever escapement, monometallic balance adjusted to temperatures, and self-compensating flat-balance spring.

They don't make stars like this anymore.

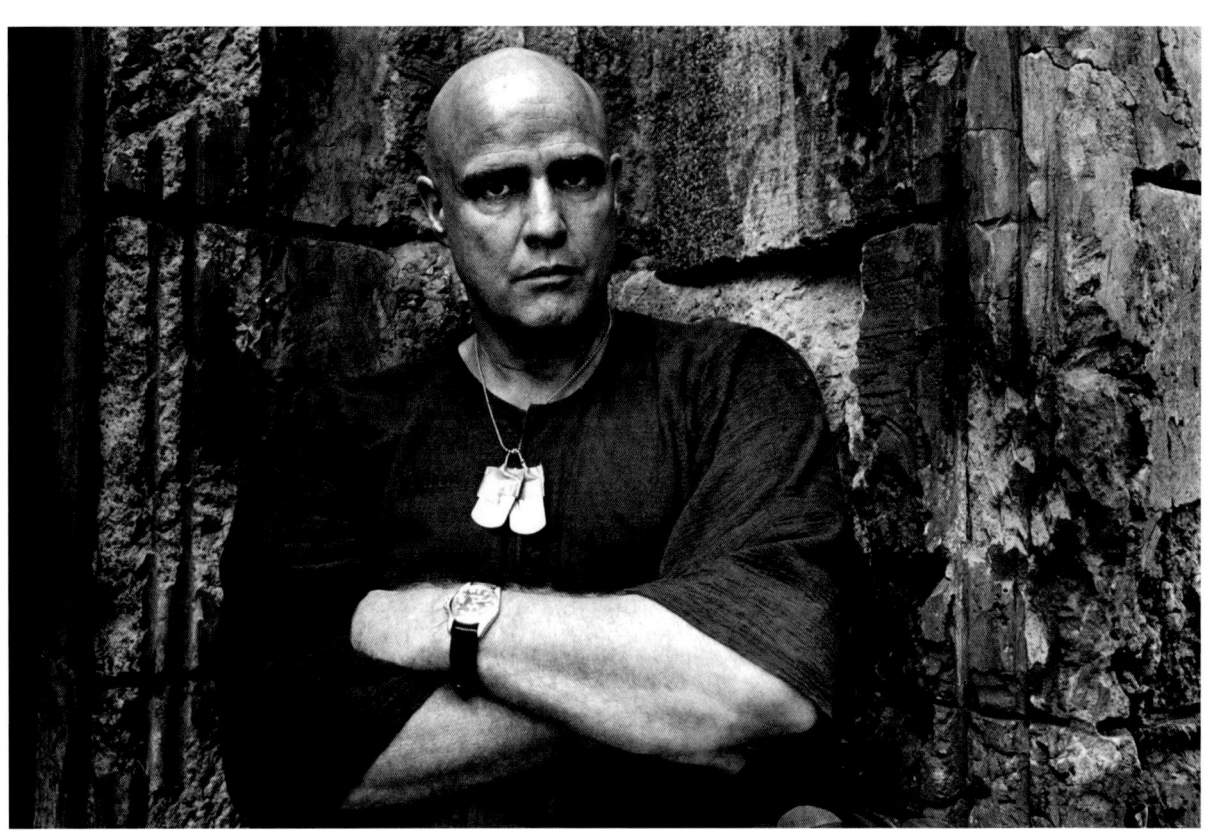

# Catherine Deneuve

"I don't have time to look backwards, because I'm looking at my present, and moving forward." —Catherine Deneuve

**LA GRANDE DAME**

Opposite. Catherine Deneuve's collection includes pieces from iconic watchmakers such as Cartier, Jaeger-LeCoultre and Patek Philippe.

Catherine Deneuve is the quintessential French movie star. With a career spanning nearly seven decades, she collaborated with the great directors of the New Wave, including Jacques Demy, Luis Buñuel and François Truffaut. In the 1980s and '90s, she won awards for her work in movies like *The Last Metro* (1980) and *Indochine* (1992). In pop culture, she was a muse for Yves Saint Laurent, an ambassador for Chanel and the face of Marianne, France's symbol of liberty. Even today, you can feel the impact of Deneuve's aloof presence in shows like *Emily in Paris*.

Born Catherine Fabienne Dorléac, the actress has always had a mysterious persona – which is one reason that she has never been tied to just one moment in time. While her screen roles are often characterised as aloof, Deneuve has a passion for (and an exquisite taste in) equally enduring timepieces.

Deneuve's horological impact goes way back to 1965, when she was introduced to international audiences as a detached and disturbed manicurist in Roman Polanski's first English language film, *Repulsion*. In press photos from that era, she is frequently pictured wearing a Cartier Baignoire. The story of the Baignoire goes back to 1912, when Louis Cartier stretched the traditional round shape of a watch to form an oval bathtub shape (*baignoire* meaning 'bath' in French). In the Swinging Sixties, the Baignoire's oversized case and graphic typography became a firm favourite among the flourishing of art, music and fashion that was taking place in London.

In the 1970s, Deneuve became the face of Chanel No. 5. As soon as she began appearing in ads for the perfume, sales soared

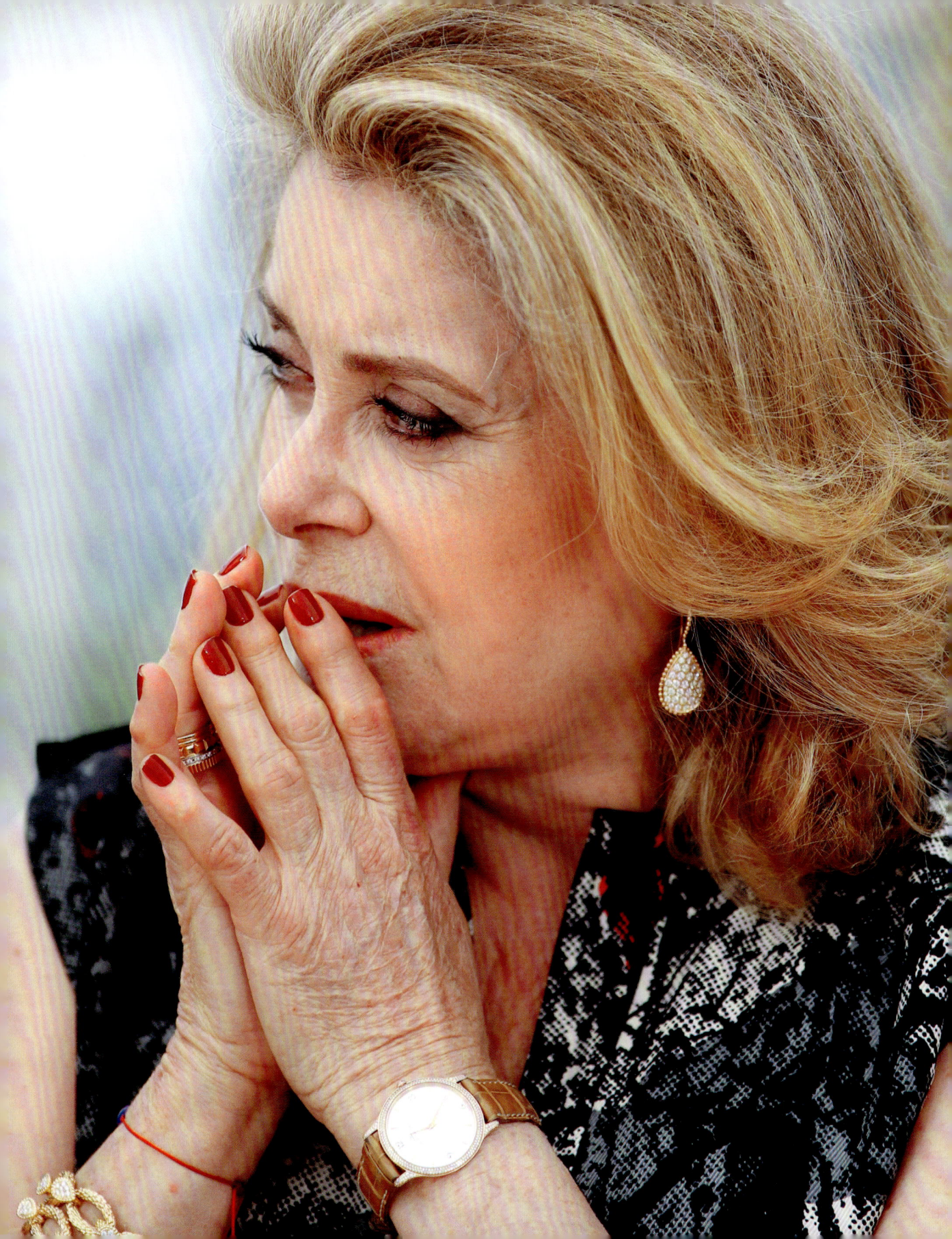

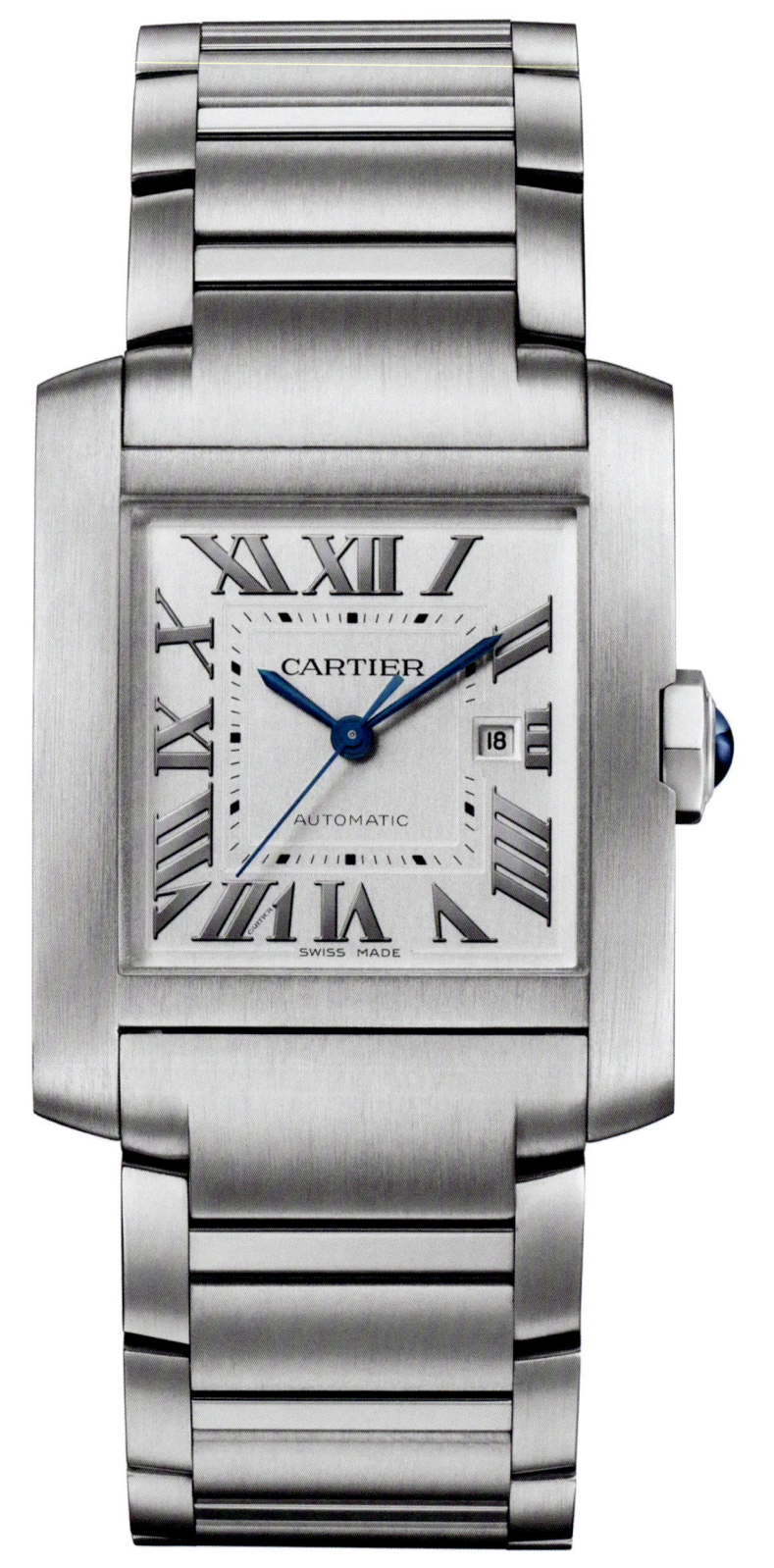

in the United States, with the American press hailing her as "the world's most elegant woman". During this time, she acquired an impossibly elegant Patek Philippe. Produced in 1976, this timepiece was meant to showcase the brand's high jewellery expertise. Beautifully set with diamonds, onyx and chrysoprase, the timepiece was sold at Phillips' Geneva Watch Auction: NINE in 2019, where it sold for CHF35,000 (around £30,000 / US$38,000).

As Yves Saint Laurent's muse of almost 40 years, Deneuve shared the designer's preference for the Cartier Tank. In most portraits, you can see YSL sporting a Must de Cartier from the 1960s; and well into the 1980s, Deneuve was frequently spotted wearing her own. In 2023, she appeared with actor Rami Malek in an advertising campaign for the revamped Tank Française.

Following her nomination for an Academy Award for *Indochine* in the 1990s, Deneuve found further fame as a model, starring in campaigns for Louis Vuitton, MAC and L'Oréal. In March 2013, *The Guardian* listed her as one of the 50 best-dressed women over the age of 50.

Deneuve is also a benefactor to filmmakers and conservationists. To recognise these contributions, in 2007 Jaeger-LeCoultre requested Deneuve's signature be engraved on a Reverso 'Grande Automatique' Ref. 3038420. This self-winding, water-resistant, rectangular, stainless-steel gentleman's reversible wristwatch was then auctioned off at the Venice Biennale to raise money for Funds for Cinema, a project promoted by La Fondazione La Biennale di Venezia to preserve old movies that are at risk of being lost forever.

Appreciative of horological history, Deneuve can often be seen wearing a Jaeger-LeCoultre 101 Etrier. This minuscule watch was the world's smallest mechanical movement when it debuted in 1929 and is still the tiniest watch mechanism in production. The modern Calibre 101 contains 98 parts in its 14mm-long, 4.8mm-wide and 3.4mm-thick case. The 101 Etrier is also a stunning example of the artistry of Jaeger-LeCoultre's *haute joaillerie* atelier. The case and bracelet of Deneuve's model are made of 18K white gold and are set with 212 square-cut diamonds for approximately 12.52 carats of stones.

Opposite. Among Deneuve's many Cartiers is the Tank Française. Here's the 2023 version in stainless steel. Image courtesy of Cartier.

Page 28. Deneuve also made wearing jewellery watches on the red carpet glamorous. Here she is at the Cannes Film Festival in 2000.

Page 29. Deneuve at the Cannes Film Festival in 1965 wearing a Cartier Baignoire.

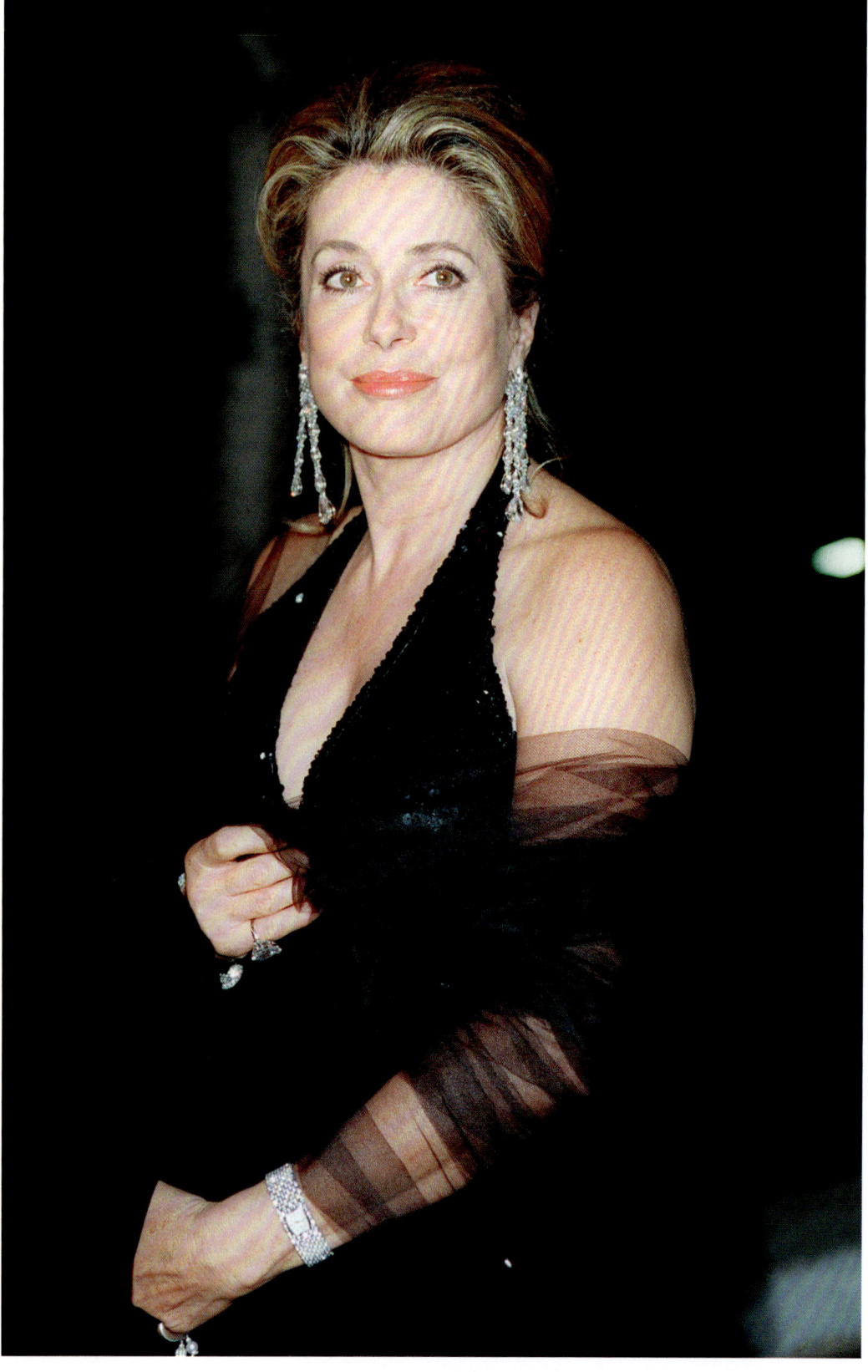

# Diana, Princess of Wales

"I don't go by the rule book... I lead from the heart, not the head." —Diana, Princess of Wales

THE CROWN JEWELS

Opposite. Diana and a young Prince Harry. Diana wears a yellow-gold Patek Philippe Calatrava Ref. 3618 with a woven, integrated bracelet.

Decades after her untimely death, Diana, Princess of Wales remains a person of fascination for millions of people. When she first became engaged to the future King of England, she was known as 'Shy Di' but as she learned to navigate palace intrigue and then later establish herself as an independent woman, she began to use her distinct personal style to express herself. Her looks are so famous that they come with special names and stories of their own. Think of the fairytale wedding dress designed by David and Elizabeth Emanuel; the Warm & Wonderful 'Black Sheep' sweater that expressed how out of place she felt in the royal court; the fitted, black, off-the-shoulder 'revenge dress' she wore the night Prince Charles announced on television that he had been unfaithful.

Just as her clothes played their part in her life story, so too does her watch collection. Beginning with a very rare yellow-gold Patek Philippe Calatrava (Ref. 3618) with a woven, integrated bracelet, this timepiece was gifted to her by her then-fiancé Prince Charles for her 20th birthday. She started a trend for 'double-wristing' when she was spotted in the stands at one of Charles' polo matches wearing her Calatrava along with her husband's gold Patek Philippe Disco Volante.

Things only got posher for Princess Diana. At her wedding to Prince Charles, the royal family of Saudi Arabia gave her a gemstone-laden Asprey timepiece, while Queen Elizabeth II presented her with a diamond-set Vacheron Constantin that she had received for her own nuptials in 1947.

For all the pomp leading up to the royal wedding, Diana soon became known as 'the people's princess', with her taste in

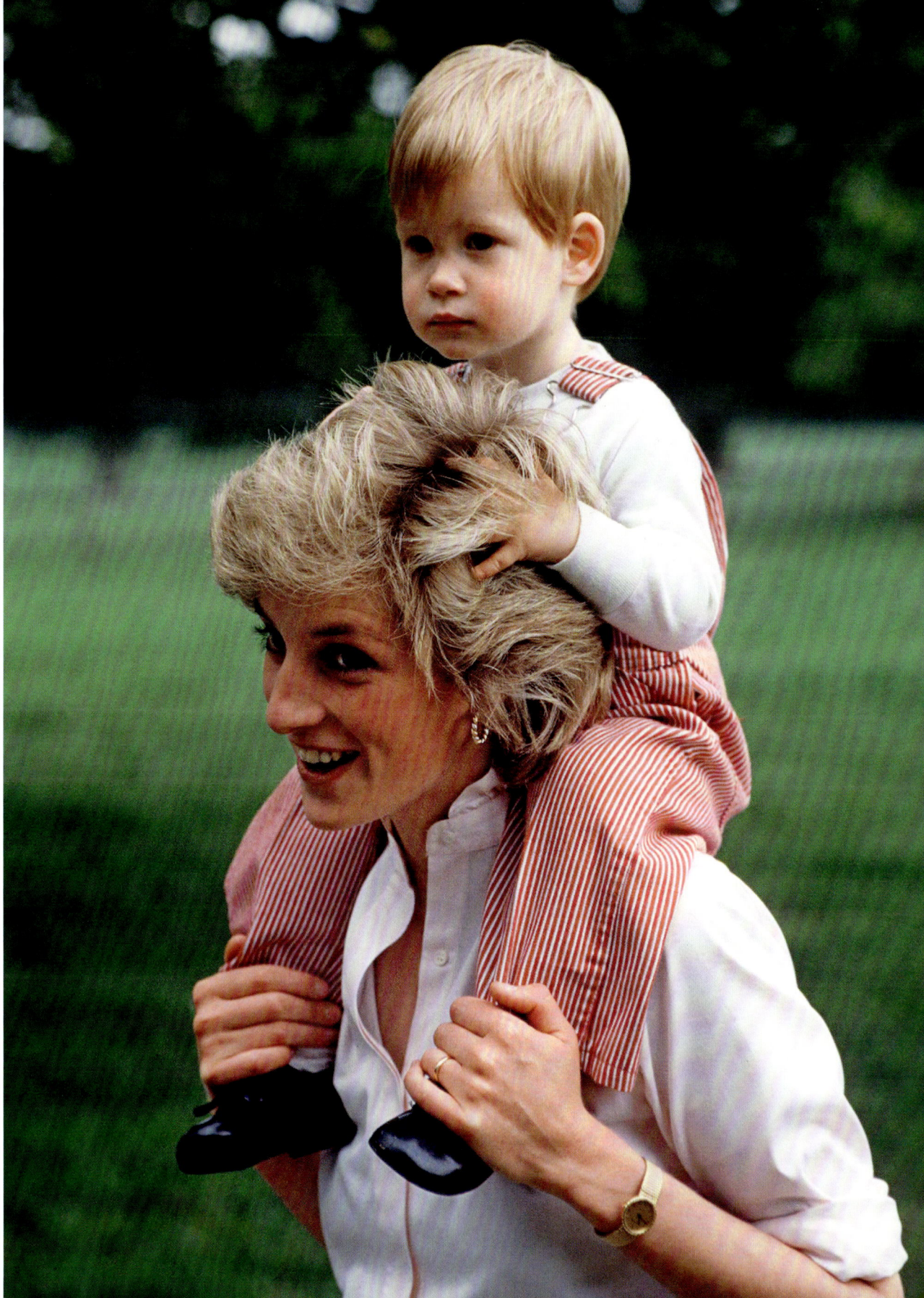

timepieces becoming more relatable to the public. In the latter part of her life, she was most frequently pictured wearing one of two Cartier timepieces: a Tank Louis Cartier watch with a yellow-gold case and black alligator strap and a Tank Française with a yellow-gold bracelet.

In the realm of watchmaking, Patek, Vacheron and Audemars Piguet are known as the 'Holy Trinity'; while Cartier, though still considered luxury, ranks far below in succession to that throne. As a result, the Tanks are relatively attainable pricewise for the everyday enthusiast. The thought that a regular collector could buy the same watch as Princess Diana is simply another way to connect with her.

These timepieces held meaning for the princess that went far beyond money and power. The Tank Louis Cartier (a gift from Diana's father John Spencer, the 8th Earl Spencer) was selected by Prince William as his personal keepsake upon his mother's death. The Tank Française, obtained around the same time as her divorce from Prince Charles, marked a newfound independence from 'the Firm'. Famously, she wore the Louis Cartier on her historic 1997 visit to Bosnia to raise awareness about the devastating effects landmines have on people's lives. This historic timepiece would go on to pass from one slender wrist to another and is now in the possession of Diana's daughter-in-law Meghan Markle.

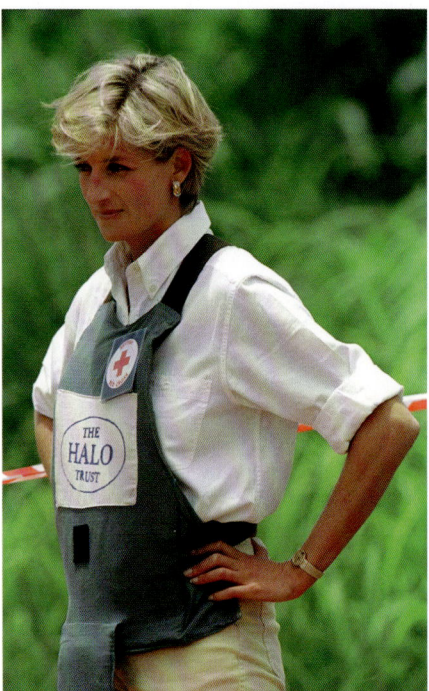

This page. Diana wearing her Cartier Tank Louis Cartier during a 1997 humanitarian mission in Huambo, Angola.

Opposite. An example of a Cartier Tank Louis Cartier that debuted at Watches and Wonders in 2025. Image courtesy of Cartier.

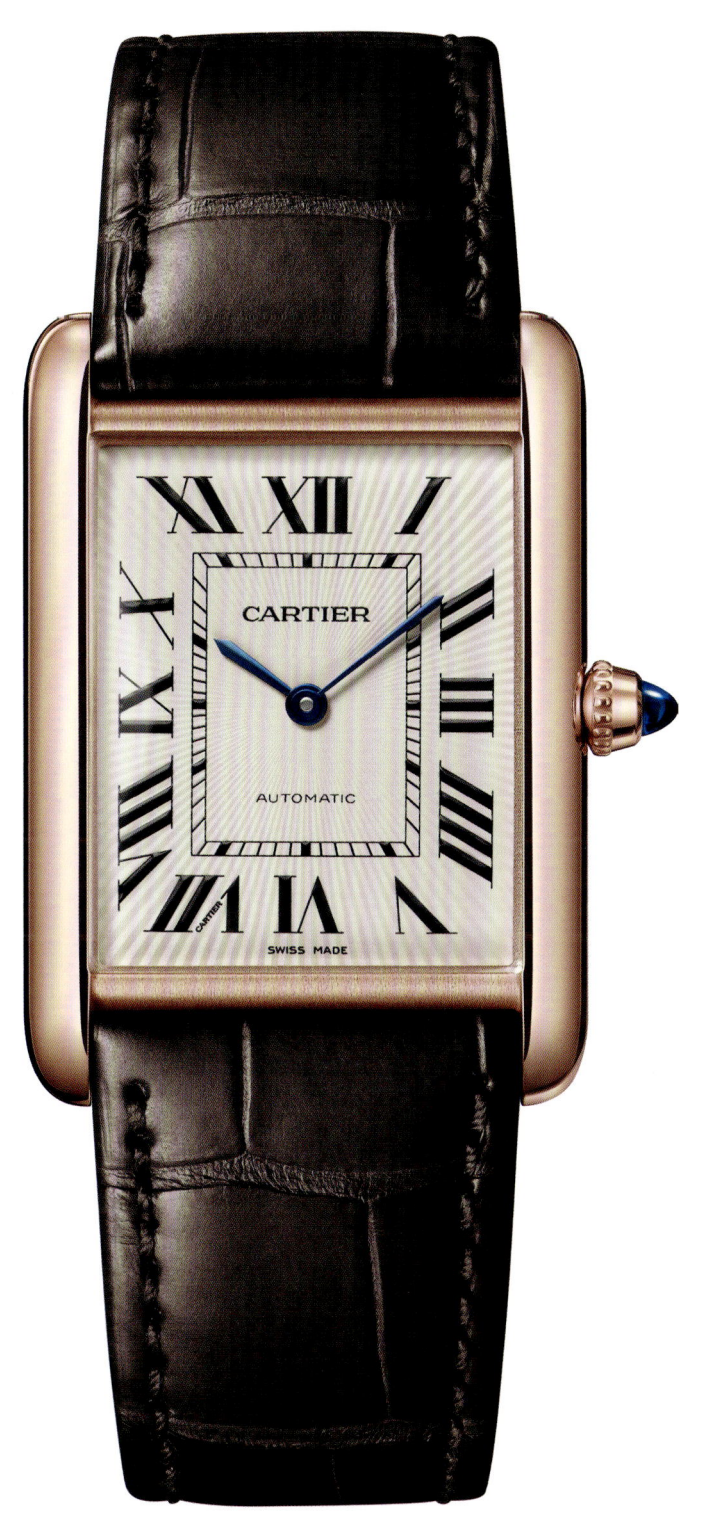

# Robert Downey Jr

"You can learn a lot about a man if you open up his jewelry box." —Robert Downey Jr

TRUE BELIEVER

Opposite. Robert Downey Jr on the red carpet for the premiere of *Avengers: Infinity War* (2018) wearing a super rare (and expensive) Greubel Forsey GMT Tourbillon.

Robert Downey Jr is the rare actor who can either coast on charisma (as he did playing Iron Man in the 2008 film of the same name) or completely disappear into a part (think Lewis Strauss in the 2023 blockbuster *Oppenheimer*, which won him four awards).

Alongside his acting talents, Downey Jr is a well-known watch enthusiast with a safe full of masterpieces from brands like Rolex, Patek Philippe and Audemars Piguet. The watch brand he seems most partial to, however, is Jaeger-LeCoultre. Following his outstanding performance in *Oppenheimer*, he wore his Jaeger-LeCoultre Reverso Tribute Chronograph to accept an award for Best Supporting Actor at the 2024 Golden Globes, and he wore a JLC Polaris to pick up yet another award for Best Supporting Actor at the Oscars.

It is the Reverso, however, that seems particularly aligned with the star's dual nature. The Reverso Tribute Chronograph, which displays the time on both sides, is the horological equivalent of those comedy and tragedy masks from drama school. On one side, Downey Jr's manual-winding watch consists of a sophisticated timepiece with a 'railroad' minute track, applied hour-markers and Dauphine hands standing out in contrast to the sober black sunray dial and a simple time-only display.

Once turned over on its cradle, the watch reveals a meticulously crafted reverse that unveils every detail of the new Manufacture Calibre 860. It's a little bit of controlled chaos, with an open-worked face revealing the mechanism of the retrograde chronograph. With all laid bare, the exquisite finish

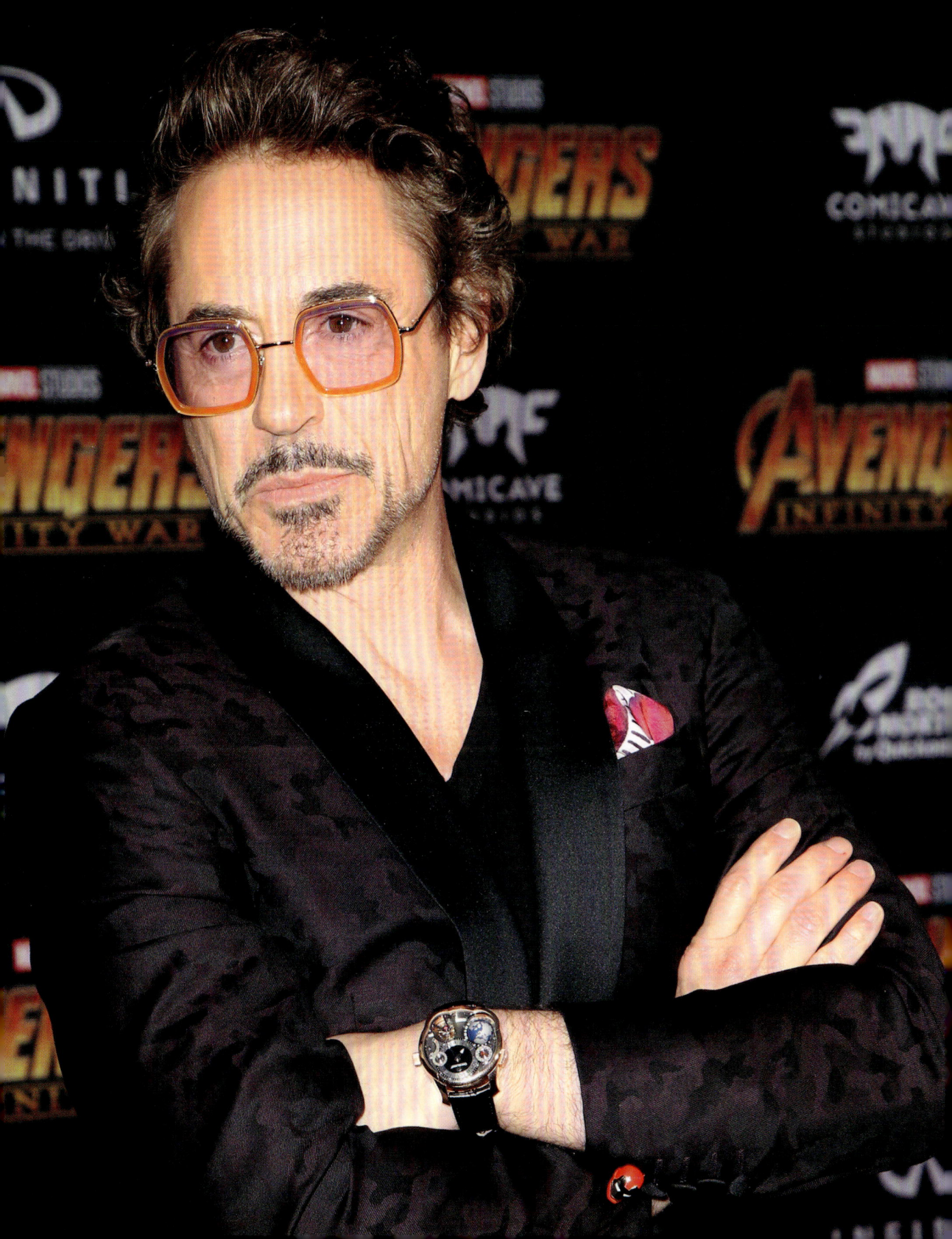

This page and opposite. The double-sided 2024 model in pink gold of the Jaeger-LeCoultre Reverso Tribute Chronograph – a favoured timepiece of Downey Jr that he wore at the Breakthrough Prize Ceremony at the Academy Museum of Motion Pictures in 2024. Images courtesy of Jaeger-LeCoultre.

of everything from the applied hour-markers and minute-track floating above the movement, to the blue chronograph hands and bevelled bridges is there for all to see.

Like the Reverso Tribute Chronograph, Robert Downey Jr's on-screen performances combine classic elements with a dandy-like flourish, which, like his distinctive wristwear, results in a mesmerising performance.

# Roger Federer

"There is no way around hard work. Embrace it. You have to put in the hours because there's always something which you can improve." —Roger Federer

POWER SERVE

Opposite. Roger Federer wearing a Rolex Oyster Perpetual Sky-Dweller at a press conference prior to the 2018 Nitto ATP Finals at the O2 Arena in London, England.

If you ever want easy access to a Rolex, all you need to do is take up an elite sport such as tennis at a young age, practise until you excel at it, and win important matches.

As an official partner of many of tennis's top matches, Rolex is almost synonymous with the sport, with winners often being presented with their own personalised timepiece. Not only that, but visit any of the Opens and you'll see oversized Rolex clocks around the grounds.

If you are a champion among champions and comport yourself with grace on and off the court, you might even find yourself as a Rolex Testimonee – an official ambassador of the brand. Roger Federer is one such elite athlete. After a 25-year career and 20 memorable Grand Slam victories, the GOAT retired from the tour in 2022, but he is still in the watch game.

The Swiss superstar began his relationship with the brand in 2009 – the year he won the French Open – wearing a white-gold Yacht-Master II at Roland-Garros. While this tool watch was originally designed for sailors, with its use of luxe materials plus its unique setting mechanism (controlled by a ring command bezel) and regatta timer, it made sense courtside at the prestigious event, too.

Since then, Federer has been spotted hoisting trophies wearing an incredible array of Rolex models: a Day-Date II in Everose gold at Wimbledon in 2012; a Rolex Sky-Dweller 326934 GMT in Miami in 2017; and wearing one of the brand's most unassuming models – the Air-King – in his last tournament at the Laver Cup in London in 2022.

This page and opposite. The Perpetual Air-King is not as flashy as other Rolex models but, like Federer, is a testament to endurance and performance. Images © Rolex.

The Air-King is a homage to aviation, but its minimalist dial is designed to offer maximum legibility in any circumstance – including high-stakes tennis matches. Like all Rolex watches, the Air-King is covered by the Superlative Chronometer certification, which promises accuracy of −2/+2 seconds per day.

Since his retirement, Federer has been a busy boy, collaborating with Loewe's Jonathan Anderson and Japanese clothing brand Uniqlo for his first fashion collection, and working with the Roger Federer Foundation to support educational projects in southern Africa and Switzerland. He has appeared at the Met Gala in New York, performed as percussionist with Coldplay in Rome, and supported the Springboks at the 2023 Rugby World Cup in France.

He has also been an enthusiastic ambassador for the game of tennis, as well as Rolex. The crown watchmakers have used the king of the sport to soft launch new models. For example, at the Laver Cup in Berlin in 2024, keen-eyed watch spotters noted that Federer had the latest black-and-grey version of the GMT-Master II wrapped around his wrist. Though he had customised this classic with a Jubilee bracelet instead of the highly popular President.

The GMT-Master II is the ultimate watch for a globetrotter like King Roger. Its two time-zone addition displays a dedicated 24-hour hand and a 24-hour graduated two-colour rotatable bezel so that the wearer can see the time in their current location as well as in another part of the world. According to Rolex, this function also allows the wearer to connect to their own personal 'somewhere out there', be it a special place, a memory, or plans for a future journey.

Federer lifting his seventh Wimbledon trophy (and a Rolex Day-Date II in Everose gold with a brown dial) in 2012.

# Ryan Gosling

"Generally the watch is a symbol that you're busy and you have important things to do and cool places to be." —Ryan Gosling

**HE SAID**

Ryan Gosling has emerged as one of the most watchable actors of his generation. From the anti-hero getaway driver in Nicolas Winding Refn's 2011 film *Drive*, to the everyman stuntman in *The Fall Guy* (2024), Gosling exudes a laid-back chill even when his body is getting beaten up on screen.

Gosling's taste in timepieces also reflects this essence of cool. In *Drive*, playing a character known simply as Driver, he wears a satin bomber jacket with a Scorpion embroidered on the back that became a cinematic icon all its own, on the level of Chris Evans's Aran knit sweater in *Knives Out* (2019) or Madonna's vintage gold jacket from *Desperately Seeking Susan* (1985). But what caught the cognoscenti's eye was an ultra-minimalist vintage Patek Philippe that Driver wore. The watch even has a backstory (it belonged to Driver's father).

In an interview in *GQ* when the film came out, prop master Will Blount revealed that the timepiece used in the movie was a fake: "You can't use the real watch or you're going to break it," said Blount. "So, we used five or six replicas." As for where they are now, Blount said Gosling asked if he could keep one of the prop watches. Blount's response: "You definitely deserve it, brother."

In 2021, Gosling signed up with TAG Heuer, bringing his modern take on masculinity to the role. The watch made an appearance in director Greta Gerwig's 2023 hit *Barbie*, with Gosling playing Ken opposite Margot Robbie's title character. If you haven't seen the movie, the dolls experience an existential crisis, and Ken suddenly starts wearing an oversized pink fur coat and not one but three different gold TAG Heuer Carreras at the same time. Since the

Above. This one-of-a-kind TAG Heuer Carrera Chronograph Gold, tailor-made for Ryan Gosling, features an 18K 3N yellow-gold 39mm case with a custom gold Milanese bracelet and a glass-box crystal. Image courtesy of TAG Heuer.

Opposite. Gosling sporting an unidentified vintage wristwatch at a photo call for his directorial debut *Lost River* at the 67th Cannes Film Festival in 2014.

This page and opposite. Gosling wore the 60th anniversary edition of the TAG Heuer Carrera Chronograph to the premiere of *The Fall Guy* in 2024. This black 39mm version of the TAG Heuer glass box with a luxurious perforated calfskin leather strap encapsulates the Carrera's signature design with a modern twist. Images courtesy of TAG Heuer.

movie was conceived as both a comment on and an exercise in marketing, it makes perfect sense in the Barbieverse.

The Carreras in question are a Ref. 1158 CHN from 1971 on an 18K gold bracelet, a barrel-shaped Ref. 110.515 from 1974 with a Côte de Genève dial, and a 1960s Carrera Ref. 2448 NT on a leather strap. These models predate Heuer's merge with TAG so are infinitely desirable for collectors, but they also mirror Ken's timeline over the years. Gosling is said to have personally picked the three gold timepieces from the brand's archives.

Neither did Gosling disappoint watch spotters in *The Fall Guy*, a reboot of the classic 1980s television series. In the movie, Gosling's character Colt Seavers, a stuntman called out of retirement to solve the mystery of a missing movie star, wears a modern-day TAG Heuer Carrera Chronograph Glassbox 39mm (Ref. CBS2210. FC6534). This reimaging of the classic 1960s reverse panda 2447 NS model was released in 2023. The watch's black dial is adorned with three sub-dials (known to watch nerds as a tricompax layout). The domed sapphire 'glassbox' crystal also gives vintage vibes and provides maximum readability. TAG Heuer's signature state-of-the-art Calibre TH20-00 automatic movement is housed in a tapered 39mm steel case.

It's pure product placement, but given director David Leitch's cheeky take on Hollywood's behind-the-scenes machinations, and Gosling's charm, the timepiece's frequent on-screen appearances fit in with the fun.

# Lewis Hamilton

"Timepieces align really well in my life because I'm literally chasing every millisecond when I'm on track." —Lewis Hamilton

### FAST TIMES

Sir Lewis Hamilton knows how to make headlines. The seven-times Formula One champion is equally admired for his abilities on the track and his sartorial skills when he's off duty.

Expressing himself through watches has been a big part of his style DNA – his first timepiece was a Mickey Mouse watch purchased at Disneyland when he was a kid, but he quickly jumped into the deep end of exclusive horology when he signed with the IWC-sponsored Mercedes-AMG Petronas team in 2012.

Even though his collection isn't exceptionally diverse (Hamilton was an ambassador for IWC for over 10 years), his loyalty to the brand is more than contractually obligated. He uses his collection to make statements, which in turn have been noted by his large following of watch spotters. Drivers are not supposed to wear watches in the cockpit, but Mercedes-AMG Petronas teammates Hamilton and George Russell all had sponsor IWC's watches embroidered on their racing gloves.

In 2022, Hamilton arrived in the paddock of the Miami Grand Prix wearing as much jewellery as he could fit on his body and alluding to the fact that he was willing to sit out races over the no-jewellery issue. Sporting at least four stacked necklaces, four rings on each hand, earrings, a nose ring and at least three watches, he told the press, "I couldn't get any more jewellery on today".

One of the watches Hamilton wore in protest was the IWC Pilot's TOP GUN 'Mojave Desert'. Originally an enormous 55mm timepiece with a pocket-watch-sized Calibre 52 T.S.C. movement, the Big Pilot's history dates to 1940 when it was made for the German

Above. The design of this platinum-cased Portugieser with a unique teal dial and diamond accents was the result of a collaboration between Hamilton and IWC. Image courtesy of IWC.

Opposite. Sir Lewis Hamilton wearing an IWC Portugieser Tourbillon Rétrograde Chronograph. Photography Chris Coe courtesy of IWC.

This page. For his first photos as a Ferrari driver, Lewis Hamilton wore a Richard Mille RM 67-02 'Italy' edition. Image courtesy of Richard Mille.

Opposite. Hamilton at the Australian Grand Prix Qualifying in 2008, wearing his TAG Heuer Grand Carrera Calibre 17.

Air Force. Hamilton wears the much more modern, 46mm, sand-coloured ceramic Mojave Desert edition launched in 2019.

On the opposite wrist, Hamilton sported a standard issue Big Pilot's, though he also launched the brand-new Pilot's Watch Chronograph 41 Edition 'Mercedes-AMG PETRONAS Formula One™ Team'. Dressed in the signature green racing colours of the Petronas team, the case of this tool watch is crafted from lightweight, grade-five titanium, which has the highest strength-to-density ratio of any metal. The Calibre 69385 movement has 231 parts and 46-hour power. It should be noted that not only was it a sponsor of Mercedes F1, but IWC was also an official engineering partner since 2013 (the year Hamilton debuted). Many of Mercedes's technical discoveries in materials were shared and used by the Swiss watchmaker.

Hamilton's collaboration with IWC produced the Portugieser Tourbillon Rétrograde Chronograph Lewis Hamilton, a timepiece that integrates a refined platinum case, a teal dial and a matching textile strap with the IWC-manufactured Calibre 89900 driving a flying minute tourbillon, a chronograph function and a retrograde date display. It took two years to develop this timepiece. Other distinctive Hamilton-inspired features are 12 diamonds on the dial and rocks on the inside of the movement – the silicone pallet lever and escape are both paved with precious stones. When it was introduced in 2023, IWC claimed that this new Diamond Shell technology increases the timepiece's efficiency by reducing friction.

With Hamilton switching over to Ferrari for the 2025 season, watch spotters were keen to see the British racer's watch collection become more diverse, particularly because Ferrari collaborates with Richard Mille. Before the season even started, the British F1 driver was seen wearing a red, white and green RM 67-02 'Italy.' The case of this 2024 edition is ultrathin and lightweight as it is crafted from Carbon TPT (layered sheets of carbon fibre) and powered by an automatic CRMA7 movement that was built to withstand shock.

It's a much more technical-looking watch but only time will tell if it will also be a good metaphor for this next stage in Hamilton's career.

Hamilton wearing an ultra-light, ceramic-cased IWC Big Pilot's TOP GUN 'Mojave Desert'.

# Kevin Hart

"My love for watches is endless. Each watch that I own tells an incredible story of my time and value." —Kevin Hart

**HART BEAT**

Opposite. Kevin Hart at the 2017 Berlin premiere of *Jumanji: Welcome to the Jungle*, wearing a yellow-gold Patek Philippe Ref. 6102R Celestial.

From a humble upbringing in Philadelphia to accolades such as being named one of the 100 most influential people in the world in *Time* magazine in 2015, it's safe to say that few stand-up comedians have achieved the supernova success of Kevin Hart. From sold-out arena tours to blockbuster movies like the *Jumanji* franchise (1995–present) and *Ride Along* (2014), Hart is known as one of the hardest-working entertainers in the business.

Hart likes to celebrate his milestones by investing in interesting timepieces. His well-curated collection of watches includes Rolexes, Patek Philippes and Audemars Piguets. His love of watches began when he was a teen admiring the arm candy of rappers and sports stars. When he started to gain mainstream success with standup comedy and a guest spot on Judd Apatow's 2001 sitcom *Undeclared*, he jumped right into watch-collecting, starting with a series of significant Rolex Daytonas.

Great comedians are experts in timing. To make a joke land, it must be polished, fine-tuned and surgically examined. Maybe this is why Hart is attracted to super-complicated timepieces. One of the most horologically intriguing examples in his watch vault is the RM 11-01 Roberto Mancini that he wore to collect his Comedic Genius Award at the 2015 MTV Movie Awards.

Introduced in 2013, this watch was designed in collaboration with former Italian soccer star (and current Saudi Arabia national football-team coach) Roberto Mancini. The dial of this flyback chronograph is configured to account for two 45-minute halves – one on each side of the dial – along with up to 15 minutes of additional stoppage time; to start the second half, you simply

press the 4 o'clock pusher to activate the flyback function and reset. The automatic Calibre RMAC1 movement also offers an annual calendar with an oversized date display placed in a green-outlined horizontal aperture under 12 o'clock.

Measuring 50 × 40 × 16.15mm, one would think that this massive timepiece would overwhelm the diminutive comedian's wrist. Yet somehow the graceful ergonomic curve of the case and the subtlety of the rubber strap make the proportions work. The case is also constructed in three parts from lightweight grade 5 titanium and has Nitril O-ring seals that make it water-resistant to 50 metres.

And even though it's a super-sporty watch, the degree of detail in the finishing – the titanium base plate and bridges are hand polished, the pivots are burnished, and the wheels are chamfered – make it feel much more elevated. It's the kind of watch that feels at home on a red carpet.

Performing in front of a stadium-sized audience requires both outsized confidence and introspection. Few watch enthusiasts have expressed their passion as eloquently as Hart did on the late-night talkshow *The Colbert Report* while promoting his film *Borderlands* in 2024. Host Stephen Colbert asked the actor about

Opposite. Hart's passion for watches goes way back. This RM 11-01 Automatic Flyback Chronograph Roberto Mancini dates to 2013. Image courtesy of Richard Mille.

This page. Keeping it casual with a limited-edition 18K rose-gold Audemars Piguet Royal Oak self-winding chronograph with a chocolate hand-stitched alligator strap and Grande Tapisserie dial.

Opposite. Hart has many Rollies, including this gold Day-Date Ref. 118238GLWAFO with a wavy pattern on the dial.

his vintage Audemars Piguet Grande Sonnerie. One of the most expressive of watch movements, a Grande Sonnerie (French for 'grand strike') is a mechanical complication with both a quarter-striking mechanism and a repeater. An internal gong is struck every quarter-hour, audibly indicating which quarter-hour it is. A second gong then indicates the number of hours. For example, at 5.15am it would strike a high-pitched gong once (first quarter-hour) and then a lower-pitched gong five times (fifth hour).

Hart explained to Colbert that his appreciation for such craftsmanship reflects his belief in the value of time, a philosophy that has informed his entire watch-collecting journey. "When I look at my watch or watches they are all a representation of time that I spent doing something that mattered the most." For example, to commemorate winning the 2024 Mark Twain Prize for American Humor, he picked out a white-gold 37mm Royal Oak Self-winding Flying Tourbillon Extra-Thin RD#3 – a watch that supposedly took AP five years of research and development to shrink down to its current silhouette.

# LeBron James

"I always liked watches growing up. When the opportunity presented itself, it was easy to say yes." — LeBron James on collaborating with Audemars Piguet

**KING JAMES VERSION**

Opposite. The Audemars Piguet Royal Oak Offshore is LeBron James' signature timepiece. The design of this oversized watch dates back to 1989 when Audemars Piguet designer Emmanuel Gueit presented a conceptual sketch of a more robust Royal Oak.

LeBron James is one of the most legendary basketball players of all time and the NBA's all-time leading scorer. In fact, his career has gone on so long that for the 2024 season, he played alongside his son Bronny with the L.A. Lakers.

He is also one of the most influential athletes in the world. Kids that grew up with his poster on their wall are now adults; and the ones that are into watches have been carefully tracking his horological legacy. An athlete, an actor, and an avid watch collector, the King's watch box is not only filled with examples from Rolex, Audemars Piguet, Patek Philippe and Richard Mille, they are usually the buzziest models, too. And once James is photographed with one on his wrist (and he is known to wear many different timepieces in one day), they only become more desirable.

Take James's Rolex collection: not only does it include some of the most accessible pieces the brand offers, but he brings a special flair to his assortment of 41mm Rolex Oyster Perpetuals by selecting fun-coloured coral-red and turquoise-blue dials. These variants started out as entry-level, but on the secondary market their prices jumped due to their popularity with stars like James.

Not only that, but James's star power has allowed him to jump the waiting lists and access to ultra-rare models such as the Oyster Perpetual Day-Date 'Puzzle Watch' from 2023. Crafted from 18K yellow, white or Everose gold, these watches have adapted the original Day-Date by replacing the day of the week with one of seven inspirational keywords in English – 'Happy', 'Eternity', 'Gratitude', 'Peace', 'Faith', 'Love' and 'Hope' – while the window at 3 o'clock displays one of 31 exclusive emojis instead of the date.

To make this timepiece even more pleasing, the dial has a jigsaw pattern created using *champlevé* enamelling.

James also has a history with Audemars Piguet. As well as having an enviable inventory of Royal Oaks, he was a one-time ambassador for the brand in 2013 and had a hand in designing the Royal Oak Offshore LeBron James limited edition – an elegant grey and rose-gold watch that anticipated (or inspired) the craze for two-toned sport watches 10 years later.

We know James loves colour, which is why the one watch that best pairs with the power forward's aesthetic is the Patek Philippe Nautilus 5711 Tiffany collaboration. This is the watch that broke the internet in 2021 when Patek Philippe announced that it was discontinuing its most famous model – the Nautilus 5711 – with it having one last incarnation in partnership with retailers Tiffany & Co.

Patek made 170 versions of this iconic watch with a Tiffany Blue dial. Billionaires and A-listers scrambled to get their hands on this limited edition. As Patek Philippe president Thierry Stern explained in a highly publicised interview with CNBC, it would be up to Tiffany to decide to whom these coveted timepieces would be allocated. Guess who got one? That's right, our man LeBron. And the best part is that James actually *wears* his watches! The Tiffany Blue recently got wrist time when LeBron opened the 100th edition of the 24 Hours of Le Mans race.

Opposite. The Patek Philippe Ref. 5711 Nautilus Tiffany 170th Anniversary Edition was limited to just 170 editions when it was launched in 2021. James was one of the lucky recipients. Image courtesy of Patek Philippe.

This page and opposite. James has an abiding interest in limited editions like this ultra-rare Rolex Oyster Perpetual Day-Date 'Puzzle Watch' from 2023. Images © Rolex.

64

# Jay-Z

"It's aspiration really. Complicated timepieces are a lot more interesting than giant gold chains or diamonds."
—Jay-Z

## MR NICE WATCH

Opposite. The blueprint. Jay-Z and his one-of-a-kind Richard Mille 56, customised with a blue sapphire case. It reportedly cost $2.5 million and took 3,000 hours to make.

Before Jay-Z, brands would try and appeal to buyers by signing on adventurers like top pilot Chuck Yeager (Rolex) or racing-car driver Michael Schumacher (TAG Heuer). Buying a timepiece endorsed by an athlete or celebrity brought you one step closer to racing in Monte Carlo or walking a red carpet. What has changed in the last 20 years or so is how luxury brands have used pop culture to reach a younger, more diverse audience. Jay-Z and his incredible collection of watches opened the door to a whole new generation and showed them that, along with cars, sneakers and jewellery, watches are an important part of living the good life.

Born Shawn Corey Carter in 1969 in New York City, Jay-Z first made chart history with his debut album *Reasonable Doubt* in 1996. One year later, he began collecting watches, and timepieces would go on to frequently figure in his lyrics as a symbol of how far he has come. His hip-hop persona is that of a man who has transcended the 'Hard Knock Life' to become both a mogul (he co-founded Roc-A-Fella Records in 1994 and served as president and chief-executive officer of Def Jam Recordings from 2004–2007) and a cultural spokesman.

He's also a born collaborator and his work with other artists has yielded number-one hits like Mariah Carey's 'Heartbreaker', Beyoncé's 'Crazy in Love', Rihanna's 'Umbrella', and 'Empire State of Mind', featuring Alicia Keys. Collaboration is also key in his watch collecting. As a self-described 'businessman', Jay-Z has parleyed his passion into some impressive partnerships.

In 2005, to celebrate his 10th anniversary in the music business, Jay-Z introduced the hip-hop nation to a new notion of

Above. The limited-edition Shawn Carter by Hublot Classic Fusion is powered by a slim 2.90mm-thick HUB1300 hand-wound movement.

Opposite. Jay-Z is big on collaborations. In 2013 he teamed up with Hublot to create the Shawn Carter By Hublot Classic Fusion in black ceramic and yellow gold.

luxury when he collaborated with Audemars Piguet on the Royal Oak Offshore Jay-Z 10th Anniversary Limited Edition. The series consisted of 100 timepieces: 50 in stainless steel, 30 in rose gold and 20 in platinum, and each edition was sold with a specially engraved Apple iPod uploaded with the artist's complete discography.

This collaboration also marks the first time the usually staid Swiss Maison partnered with the world of hip-hop, but it wasn't the last. Almost two decades later, AP recently paired up with Houston rapper Travis Scott to create the AP Royal Oak Perpetual Calendar Openworked 'Cactus Jack' – a watch and accessory collection that sold out in seconds.

During a 2019 show in his hometown of Brooklyn, Jay-Z dedicated a verse to his custom Richard Mille 'BluePrint' – a watch that, according to *GQ* in 2019, required more than 3,000 hours to produce. No wonder it cost $2.5 million.

Opposite. Jay-Z courtside wearing an Audemars Piguet Royal Oak Perpetual Calendar Openworked Ceramic Ref. 26585CE.

Perhaps the greatest testament to Jay-Z's love of high-end horology is that he has never been beholden to one brand. You can find references to brands such as Rolex, Jaeger-LeCoultre and Audemars Piguet in his lyrics, such as when he announced his love of both Hublot and Rolex in the 2011 song 'Otis'. In 2013, Hublot returned the favour by collaborating with the rapper to design the limited-edition Shawn Carter Classic Fusion in yellow gold and black ceramic. Jay-Z had a huge hand in the design of this watch, insisting on a distinct, skeletonised dial and a slim-case silhouette. Ahead of its time, this edition is now much sought after by collectors. "We spent a lot of time choosing the right materials and getting the logo right... I wanted to work with the best. I did not want a cookie-cutter watch," said Jay-Z when the watch was launched. "This is not a copy-and-paste thing. Everything was done with the highest level of integrity."

# Elton John

"I collect for the beauty, not the value. I'm in awe of these things." —Elton John

WRIST ROCKETS

When Sir Elton John and his husband David Furnish sold their long-time Atlanta residence in 2024, his fans were offered a rare glimpse of the musician's many material interests. The condo was filled with furniture, photographs, fashion, jewellery and, of course, watches. An auction of the estate held at Christie's was comprised of eight sales in total, both live and online.

To provide a sense of the scale of the event, titled 'Sir Elton John: Goodbye Peachtree Road', there were 921 lots in total and 31 of these were timepieces. And the auction only represented the goods from one residence. John and Furnish are also said to own retreats in Los Angeles, Windsor, Venice, Nice, and Stouffville, Ontario in Canada. Presumably, each home is stuffed to the rafters with esoteric treasure.

Sir Elton's taste in timepieces has always been equally extravagant. His collection includes examples of the most daring watch designs from equally outrageous brands like Franck Muller (in *Interview* magazine, he called Muller the 'Picasso of watches') and Cartier. In a 1980 clip from *The Tomorrow Show*, John told host Tom Snyder a story about his jewellery while wearing a gold Cartier Santos and singing an a cappella version of a ditty called 'Cartier'.

His devotion to all things Cartier is perhaps best illustrated in Lot 12 of the Christie's 'Goodbye Peachtree Road' catalogue. This is, of course, John's very rare 18K-gold, limited-edition, asymmetrical wristwatch with a 'Crash' case and deployant clasp. The surrealistic look of the Crash has become a must-have among a new generation of collectors such as Jay-Z and Kim Kardashian, and John's version is just about the most extreme iteration of this model ever produced.

Above. This Cartier Crash was one of the many timepieces sold at the Christie's 2024 'Goodbye Peachtree Road' auction. Courtesy of CHRISTIE'S IMAGES LTD. 2025.

Opposite. Sir Elton wearing a Franck Muller Vanguard Chronograph.

Above. The Christie's 2024 'The Collection of Sir Elton John: Goodbye Peachtree Road' auction also included this customised platinum Jaeger-LeCoultre Master Control Automatic Triple Calendar with a pointer date. Courtesy of CHRISTIE'S IMAGES LTD. 2025.

In comparison, you'd think a Rolex Daytona would be too tame for Elton John, but Lot 9 was described in the Christie's catalogue as an "exuberant and rare 18K gold, diamond and orange sapphire automatic chronograph wristwatch with 'Leopard' Dial". This paragraph completely undersells the audacity of the gem-studded 2001 timepiece.

That doesn't mean that John is only concerned with bling: one of the most horologically interesting pieces in the Goodbye Peachtree Road collection was a 2000 platinum Jaeger-LeCoultre Master Control Automatic Triple Calendar with a pointer date. Granted, he did customise this super-complicated watch with diamonds, diamonds and more diamonds, but that's just one more thing to admire about John's taste in timepieces – he makes them his own!

Philanthropy is another important part of John's non-musical legacy. He is most frequently photographed wearing a Chopard Imperiale. Over the years, he has also partnered with the brand to create limited editions to raise money for the Elton John AIDS Foundation. In 2010, as a tribute to John's unwavering activism, Chopard created a one-of-a-kind, blue-dialled, automatic chronograph flanked by two diamond-set skulls.

Left. Also from the Christie's auction, a unique, far-from-understated, diamond-encrusted, skull-themed piece from Chopard. Courtesy of CHRISTIE'S IMAGES LTD. 2025.

Right. Another rarity from the 'Goodbye Peachtree Road' auction: a wild Rolex Daytona studded with diamonds and orange sapphires. Courtesy of CHRISTIE'S IMAGES LTD. 2025.

# John Mayer

"The difference between a collector and a consumer is knowing the details, and I live for the details." —John Mayer

Opposite. John Mayer's watch collection contains many deep cuts, including this Rolex GMT-Master II 'Batman' on a Jubilee-style bracelet.

John Mayer is a rabid watch enthusiast who just happens to be a celebrity on the side. The American singer-songwriter is so involved in the community that he's a regular contributor to *Hodinkee*, a major watch platform on the internet, and has also served on the jury of the venerable Grand Prix d'Horlogerie de Genève – the Academy Awards of watchmaking.

Celebrities don't just influence their fans; they also influence one another. According to Ed Sheeran – no slouch when it comes to collecting – "I got into watches a while ago through John Mayer, actually". While co-hosting BBC Radio 2 with Jo Whiley, Sheeran explained: "He's always been someone I've always looked up to and he also looks up to Eric Clapton, who is also a collector of watches."

Like Clapton, Mayer is both a guitar and watch savant. His collection started out strong right out of the gate – he bought a Rolex Explorer II with his first record company pay cheque. In an article published by *Hodinkee* in 2015, he wrote that he followed up with an IWC GST Chronograph in titanium.

To illustrate the role watches play in his persona, his next big purchase was an IWC Big Pilot Ref. 5002. "Not only did it become my favorite watch, but it also took on a much larger role as a personal identifier; 'Big Pilot' became my code name on the road, and the 12 o'clock indicator even made it on the twelfth fret of my Martin signature acoustic guitar."

*The New York Times* estimates that Mayer's collection is valued in the millions. The effect it has on the collecting community, however, is incalculable. While he has collaborated with brands as wide-ranging as G-Shock to Audemars Piguet, he's largely a

This page. At a benefit for the Heart and Armor Foundation in 2023, Mayer rocked a limited-edition Audemars Piguet Royal Oak Concept Tourbillon 'Spiderman'.

Opposite. Every collector's dream is to have a watch named after you. Mayer and watch blog *Hodinkee* have collaborated with G-Shock on three separate launches: the G-SHOCK Ref. 6900 By John Mayer, the G-SHOCK Ref. 6900-PT80 By John Mayer, and – pictured here – the G-SHOCK Ref. 6900-PT1 By John Mayer. Photography Mark Kauzlarich courtesy of *Hodinkee*.

free-agent, unbound by the corporate commitments of brand ambassadorship. When Mayer wears a watch, you know it's because he loves it. Not only has this air of authenticity served to boost the value of any watch he wears, but some would say that Mayer's deep dive into historic timepieces has changed the entire game of vintage watch collecting.

Even his most recent collaborations are retro. Inspired by Mayer's very first Casio keyboard, the Casio G-Shock Ref. 6900-PT1 By John Mayer has a very '80s matte dusty blue with peach, coral and turquoise hues found on the Casio PT-1 keyboard. Darker grey was pulled from the keyboard's sharp and flat keys and added to the watch's illuminator button. Mayer has worked with Casio on three different timepieces, all riffing on the classic DW-6900. Just as these instruments served as an entry point into the world of music, G-Shocks are a great gateway into the world of watches.

Mayer has also collaborated with watch brand Audemars Piguet on several projects. In 2024, the musician partnered up on the limited-edition Royal Oak Perpetual Calendar John Mayer, whose iconic octagonal shape is realised in white gold across the entire body. The most eye-catching feature is the watch's blue 'Crystal Sky' faceted dial. This scintillating effect is achieved by using a brass dial plate composed of irregular shapes, whose sharp angles and facets resemble crystals. It's a big departure from the Royal Oak's traditional tapisserie pattern on the dial, but the timepiece has already become a grail watch. And it has also been spotted on the wrists of at least one other celeb – the singer Luke Combs.

Above. Mayer teamed up with Audemars Piguet to create the last iteration of the limited-edition Royal Oak Perpetual Calendar, equipped with the manufacturer's self-winding Calibre 5134. Shown here in celebration at the 'Beneath the Crystal Sky' event, held on 16 April 2024 in Los Angeles, California.

Opposite. Mayer's incredible Rolex 'Hulk' – a Supercase Ceramic LV Submariner – takes the stage at Red Rocks Amphitheatre in 2010.

# Steve McQueen

"I worked hard, and if you work hard you get the goodies." —Steve McQueen

RACE AGAINST TIME

Above. One of the six Heuer Monaco's that Jack Heuer sent to the set of the Steve McQueen movie *Le Mans* (1971). Image courtesy of Sotheby's.

Opposite. Steve McQueen wearing the infamous Heuer Monaco on the set of *Le Mans*, 24 June 1971 in the city of Le Mans, Northwestern France.

Steve McQueen was one of the most charismatic men to light up the big screen, and his cinematic wrist wardrobe was just as inspiring. While a prop master or wardrobe designer picked out the actor's onscreen timepieces, he personified them.

In the action thriller *Bullitt* (1968), McQueen's horological co-star was the civilian variant of a 1960s military-issued Benrus 3061. In the Second World War-drama *The Great Escape* (1963), McQueen's character marked his time in the cooler planning his breakout, while wearing a Rolex Speedking.

McQueen's onscreen persona of an adrenaline junkie and watch collector was much the same offscreen. He was an avid motorcycle and racing-car fanatic with the peak of his racing career seeing him achieve second place at the 12 Hours of Sebring on 21 March 1970. As for his offscreen watch collection, it contained everything from diver (a Rolex Submariner Ref. 5512) to pilot watches (the German-made Hanhart 417 ES Chronograph).

The timepiece that is most associated with McQueen, however, is the Heuer Monaco Gulf. The 1960s and '70s were a golden age of both auto racing and chronograph watches, representing the pinnacle of mechanical engineering while pushing the boundaries of cool style. The Monaco Gulf is one of the ultimate examples of timing from that era. It is also one of the first watch collaborations, born from a partnership between the oil company and Heuer before it merged with TAG. This version of the square Chrono is most notable for incorporating the vibrant-blue and vivid-orange livery of the Gulf-sponsored JW Automotive Engineering, which won the 24 Hours of Le Mans in 1968, 1969 and 1975.

Above. Steve McQueen as Frank Bullitt on the set of *Bullitt* (1968) wearing a Benrus Series #3061, a civilian version of a military-issued field watch.

Opposite. Heuer chose the radical square shape of the Monaco to draw attention to the newness of the automatic chronograph movement. Image courtesy of Sotheby's.

McQueen hoped to follow up his success at Sebring at Le Mans, but the movie studio's insurance companies squashed that dream. Instead, he participated in the movie version instead. In June 1970, Jack Heuer sent six of his brand's square-cased chronographs to the set of *Le Mans* (1971). Two of the pieces now rest in TAG Heuer's museum and McQueen gifted another to his personal mechanic Haig Alltounian on the last day of shooting.

In December of 2024, Sotheby's New York brought a fourth McQueen-worn Monaco to auction. This model was previously owned by another autosport-connected figure – young mechanic Bevan Weston, who worked on *Le Mans* and bought the watch at a discount when the movie wrapped. Later, he would go on to work for McLaren and, in 1971, was part of their Indy 500 team, wearing none other than the Monaco Gulf.

# Lionel Messi

"In football as in watchmaking, talent and elegance mean nothing without rigour and precision." —Lionel Messi

THE PLAYER

Lionel Messi gets around.

In his 20-plus-year career, beginning in 2004, the fabulous forward has not only fronted the Argentine, Barcelona, Paris Saint-Germain and Inter-Miami squads, he has made a record-breaking 26 World Cup and 39 Copa América appearances, not to mention winning eight Ballon d'Ors – more than any other player in history.

Messi's talents are so great that teams have been built around him. The same logic applies to watches. In 2012, Audemars Piguet introduced a limited-edition Royal Oak Chronograph dedicated to Messi. Only 1,000 timepieces were made: 500 in stainless steel, 400 in red gold, and 100 in platinum, all featuring a bezel made from tantalum, a rare, corrosion-resistant metal. Despite this, the Leo Messi Royal Oak is not an 'Off-Shore' (a watch designed for harsh environments), unlike other popular AP lines among sport stars.

Another distinctive feature of this limited edition is the elegant dial; instead of featuring the usual 'tapisserie' motif that is the Royal Oak's signature, the face has a vertically brushed anthracite surface.

The AP was not to be the last of Messi's collaborations with a luxury watchmaker. In 2019, Messi teamed up with Jacob & Co. for an over-the-top timepiece called the Epic X Chrono Messi. If the Royal Oak emphasises elegance, this series represents pure opulence.

For this watch, Messi's name and a dramatic calligraphic 'M' are inscribed at 6 o'clock. The footballer's signature is also inscribed on the case back. The 10-minute marker on the dial is

Above. The platinum version of the Royal Oak Leo Messi chronograph.

Opposite. Lionel Messi mixing high and low style in a hoodie and a Jacob & Co. Epic X Chrono Messi. Image courtesy of Jacob & Co.

Above. Messi likes to celebrate his career highlights by treating himself to some impressive watches. Here he is wearing the Patek Philippe Flyback Chronograph 5905R 'Blue' in 18K rose gold before an Inter-Miami CF match in 2023.

Opposite. The 41mm Royal Oak Leo Messi Limited Edition was one of the football legend's first collaborations. Image courtesy of Jacob & Co.

offset in red to accentuate the football player's jersey number and the Argentine flag is the inspiration behind the blue-and-white colour scheme of the bezel and dial.

If that isn't enough bravado, Jacob & Co. later introduced two more models to the series, including a $150,000 diamond-baguette-set version.

# Paul Newman

"If you remember to wind it, it keeps pretty good time."
—Paul Newman on the Rolex Daytona

RACING TIME

Opposite. Paul Newman is synonymous with the Rolex Daytona, but he also looked effortlessly cool in this digital watch on the set of *Fort Apache, The Bronx* (1981).

Paul Newman was many things: an actor, a racing-car driver, a husband, a father, and a civil-rights activist. But when it came to watches, he was a one-brand man. Specifically, he was a Rolex Daytona guy. His devotion to the iconic chronograph is so great that the vintage Ref. 6239, with its panda display and red minute scale, is universally acknowledged as the Rolex Daytona 'Paul Newman'.

The Daytona was originally created in 1963 with the goal of marrying a stylish design with a reliable chronograph and tachometer metric scale. Its bold, easy-to-read display was well suited to meet the needs of drivers, who could then accurately calculate average speeds of up to 400 kilometres or miles per hour.

When the 6239 was introduced in the 1960s, the Presidential Day-Dates and Submariner skin divers were the dominant watches in Rolex's catalogue. The Daytona 6239 was only produced for about six years and only in small numbers, which brings us to the power that a well-loved celebrity can have on the popularity of a watch. While Newman was an early adopter of the sporty 6239, his absolute obsession with motorsport began while training at the Watkins Glen driving school in preparation for the 1969 film *Winning*. By 1972, he was competing in his first professional event as a racer under the name P. L. Newman. And this is how his historic association with the Ref. 6239 began.

Newman was at his creative peak in the 1970s, making box-office blockbusters such as *Butch Cassidy and the Sundance Kid* (1969), *The Sting* (1973) and cult classic *Slap Shot* (1977). His popularity as an actor and as a timeless style icon continued well into the 1980s with dramatic parts in films like *Absence of Malice* (1981), *The Verdict*

Above. Newman was gifted this special reference 16520 'Zenith' Daytona when he won the Man of the Year award, presented at the 24 Hours of Daytona race. This timepiece was part of the catalogue of Sotheby's 'Important Watches Auction' in 2023. Image courtesy of Sotheby's.

Opposite. This Daytona was a hit in the Sotheby's 'Important Watches Auction' in 2023 because it was both Newman-owned but also because it is powered by a special reference Calibre 16520 'Zenith'. Image courtesy of Sotheby's.

(1982) and *The Color of Money* (1986), in which he wore a Datejust. At the same time, the public's taste in timepieces started to shift in favour of the sport-chic stylings of the Daytona.

Newman fans often spotted him wearing some variation on the Daytona. Specifically, the Ref. 6239. Because this version was only produced in small batches, it meant that it was exclusive – catnip for collectors. With the Ref. 6239, Rolex also introduced a new style of dial known as Exotic, which made it even more alluring for vintage enthusiasts.

Another notable Daytona from Newman's personal collection was a Ref. 6263 Big Red, which featured a reverse panda design with a black dial and silver sub dials. It had been gifted to him by wife and fellow actor Joanne Woodward in 1983 for their 25th wedding anniversary, marked with a warning on the back: 'Drive Slowly'. In

Above. In 2017, this stainless-steel Rolex Daytona, owned by Newman, sold for a world record-breaking $17.8 million as part of Phillips' 'WINNING ICONS – Legendary Watches of the 20th Century' auction. Image courtesy of Sotheby's.

Opposite. A portrait of the actor with one of his three Rolex Daytonas.

fact, Woodward should really get more credit for the popularity of the Daytona since she most likely presented Newman with most of his known Rolexes. The three authenticated Newman-owned Daytonas all bear similar inscriptions; the other two being 'Drive Carefully Me', which was etched into the back of his famous 6239, and 'Drive Very Slowly' etched onto a white-gold Daytona with a black dial from 2008.

In 1995, Newman was awarded a Rolex 'Zenith' Daytona after he won the GTS-1 class at the 24 Hours of Daytona. The remarkable achievement made Newman, at 70, the oldest driver to win the race.

Today, the Paul Newman Daytona can be measured in its popularity on the secondary market. Newman's own panda chronograph 6239 sold for $17 million in 2017, making it the most expensive wristwatch to have been sold at auction to that date. As of 2021, it's been on display at the Academy Museum of Motion Pictures in Los Angeles.

# Brad Pitt

"Watches are one of the few opportunities to express yourself and for me, a watch is the most steadfast symbol of what we value." —Brad Pitt

METHOD TO THE MADNESS

Opposite. Actor Brad Pitt wearing a Breitling Premier B01 Chronograph 42 Norton AB0118A21B1A1 at the premiere of *Once Upon a Time in Hollywood* (2019).

Most collectors are obsessed with more than one thing. For example, some of the watch world's best-known watch addicts also have other big-ticket collections. Comedian Jerry Seinfeld has garages filled with cars and is said to own every Breitling watch model available (he's frequently photographed sporting a Navitimer). Amassing art and examples of the Audemars Piguet Royal Oak Concept collection makes musician and producer Pharrell Williams happy. And actor Brad Pitt collects vintage works by architects including actual buildings.

Pitt is particularly fond of vintage watches, and this is reflected in his onscreen wardrobe in films like 2004's *Ocean's Twelve* in which his character Rusty Ryan wore a platinum Rolex Day-Date as he accompanied his fellow ex-cons on a romp across Europe.

In the 2019 Quentin Tarantino flick *Once Upon a Time in Hollywood*, Pitt co-starred with a chunky 1972 Citizen 8110A. Called a 'bullhead' because of the placement of this chronograph's pushers, it's not a super expensive watch (you can find it on an online auction house for about $400), but it boasts a sturdy Calibre 8110 automatic chronograph. The brand produced many iterations of this chrono, but the gold-tone version seen in the movie best fits the film's Seventies groove.

It also makes sense that, given Pitt's appreciation for modernist architecture, he would be attracted to the angular designs of the legendary Gérald Genta, a cult figure among watch enthusiasts. The Swiss watchmaker practically invented the sport-chic style of slightly oversized, stainless-steel timepieces. His most groundbreaking designs from the 1960s and '70s include the

Universal Genéve Polerouter, the Omega 'Pie Pan' Constellation, the Audemars Piguet Royal Oak, the Patek Philippe Nautilus, and the IWC Ingenieur.

To get into his role as a washed-up driver in the 2025 racing-themed movie *F1*, Pitt was seen on set wearing a 1976 Genta-derived IWC Ingenieur SL Ref. 1832. IWC is a sponsor of the Mercedes-AMG Petronas team, so the watch might have also served as a talisman to the super star. Also launched in 1976 was the Genta-designed Patek Philippe Nautilus. With its shoulders-out profile, textured dial, and H-link style bracelet, the model set the tone for the brand's integrated-bracelet sports watch.

Pitt appeared on the cover of *GQ*, promoting his action comedy *Wolfs* (2024) and wearing his personal 38mm Ref. 3800/1J, a solid-gold watch from 1981, which is a smaller version of the groundbreaking 42mm Ref. 3700, nicknamed the 'Jumbo'. And lest you think Pitt is a Johnny-come-lately in the watch world, the Oscar winner has quite a complement of Nautilus timepieces, including an example of the first model produced, the 3700.

"I'm a watch guy!" Pitt told the *Watchonista* blog when he was a brand ambassador for Breitling. "It's about quality, precision, and timeliness. I actually pride myself on always being on time."

Opposite. Pitt is a fan of vintage watches, like this Gérald Genta-designed IWC Ingenieur SL Ref. 1832. Image courtesy of IWC.

# Rihanna

"I don't do things for the response or for the controversy. I just live my life." —Rihanna

THE QUEEN OF TIME

Opposite. Rihanna's passion for high-jewellery watches, like this Chopard L'Heure du Diamant oval watch crafted with 18K white-gold and white diamonds, has inspired a new generation of collectors.

It's estimated that Barbadian singer Rihanna is worth $1,700,000,000, with most of that money coming from entrepreneurial endeavours like her cosmetic and fashion brands. You would rightly assume that a woman of taste and means can afford the best in timepieces. But it's how Rihanna wears watches that makes her the queen of watch collectors.

Born Robyn Rihanna Fenty, her style has always been about layering glamour, drama and casual clothes. While she has been spotted wearing the usual celebrity suspects such as Rolex, Piaget, Patek Philippe and Cartier, it's notable that whichever brand she wears she puts her unique spin on it.

Rihanna's first big horological moment came in 2008. Well before boyfriend watches became a thing, Rihanna wore a plus-sized Piaget Polo New Style in her 'Take a Bow' music video.

For her 2009 track 'Rude Boy', Rihanna incorporated elements of her West Indian upbringing with elements of dancehall and ragamuffin. The video, directed by Melina Matsoukas, (who also directed the 2019 award-winning film *Queen & Slim*) represents a bold stylistic bridge between Rihanna's young street-style tastes and her Piaget-era image. With references to 1980s stars like Keith Haring, Jean-Michel Basquiat and Grace Jones, it felt on point that the singer wore an armful of candy-coloured G-Shocks and Baby Gs in the promotional clip.

That video was the first to show Bad Girl RiRi's talent for wearing watches in unusual ways. But certainly not the last. In a photograph published on Instagram announcing her first pregnancy, the singer was pictured strolling through the streets of

Harlem with her boyfriend A$AP Rocky and wearing a pink puffer and an asymmetrical 18K gold Rolex King Midas that had been customised by jeweller to the stars Patcharavipa Bodiratnangkura.

Her Super Bowl LVII halftime performance in 2023 also doubled as her second pregnancy reveal. Here she tipped her hat to hip-hop culture by dancing in a red, specially designed Loewe flight suit with matching Salomon sneakers and the bedazzling Jacob & Co. Brilliant Skeleton Northern Lights watch.

Her affinity for Jacob & Co. is matched only by her ability to wear a $94,000 watch as freely as she wore her Casio Shocks in 2009. At Pharrell Williams' Louis Vuitton debut runway presentation in Paris in 2023, Rihanna was spotted wearing a customised Brilliant Flying Tourbillon watch paved in 339 baguette-cut diamonds as a choker around her neck. A few months later, at the Las Vegas F1 Grand Prix, she went for a stroll with another Jacob & Co. timepiece, this time worn around her ankle. The custom-made 18K white-gold anklet watch was adorned with 155 emerald-cut stones (mostly emerald-cut diamonds).

The most exciting thing about Rihanna's love of watches is that it has inspired excitement for timepieces in women of every stripe around the world. In the days after photos appeared of Rihanna sitting in the front row at Louis Vuitton, for example, influencers were popping up all over social media wearing everything from vintage Swatch double tours to Cartiers slipped onto ribbons wrapped around their necks. Even Taylor Swift turned up at the 2024 Grammy's wearing a vintage Concord watch set on a black diamond Lorraine Schwartz choker.

Above. Ri-Ri wore a now discontinued Piaget Polo in her 2008 'Take A Bow' video. We can picture her updating the look with this 2024 Polo Date Rainbow. Image courtesy of Piaget.

Opposite. Rihanna wore the Jacob & Co. Brilliant Skeleton Northern Lights for her Super Bowl LVII half-time show. A fitting choice because the timepiece is inspired by the dancing shapes of the aurora borealis. Image courtesy of Jacob & Co.

103

# Cristiano Ronaldo

"I've always dreamed of having my own watch collection."
—Cristiano Ronaldo

### DEFYING GRAVITY

Opposite. In 2010, the Real Madrid star Cristiano Ronaldo teamed up with independent watchmakers Time Force Watches inspired by CR7 himself.

When footballer Cristiano Ronaldo loves something, he puts his money where his mouth is. Not only does he draw a $213 million yearly salary from hit club Al Nassr, he signed a deal with Nike to be a lifelong ambassador. He has also invested in gastronomic restaurant Zela in London, along with Rafael Nadal and Enrique Iglesias, as well as a joint venture with Portuguese tourism and leisure group Pestana to open a hotel chain under the CR7 brand. His brand (number seven being his shirt number) sells a whole host of products from water, wellness experiences, clothing and fragrances.

And considering that Forbes named him the world's highest-paid athlete in 2024, he has a lot of cash to invest in his considerable passion for timepieces. In fact, that same year, the Portuguese superstar joined the billion dollar-valuated Chrono24 as an investor!

But what is the most Ronaldo-esque timepiece in his collection? One could argue that the Jacob & Co. x CR7 Epic X collection was specifically designed to reflect Cristiano Ronaldo's larger than life image. Because Ronaldo is a savvy businessman, the limited-edition, $1.3 million timepiece was touted not as a collaboration, or as a watch simply designed for collectors, but as a business venture in which Jacob & Co. designs and manufactures timepieces after the image of Cristiano Ronaldo.

The most impressive, non CR7 branded timepiece in Ronaldo's safe is a Girard-Perregaux Planetarium Tri-Axial Tourbillon. The main attraction of this ultra-complicated dial is a 3D terrestrial globe that rotates in 24-hour intervals. The case design incorporates two sapphire-crystal domes with an opening on one

This page. There are many different models in the Jacob & Co. x CR7 Epic collection. This stainless-steel 'Heart of Cry' Edition is the most understated. Image courtesy of Jacob & Co.

Opposite. The CR7 Epic collection is a fun watch, with the skeletonised movement visible through the caseback. Image courtesy of Jacob & Co.

side allowing the wearer to admire the surface of the mini hand-painted planet. The depths of the Tri-Axial tourbillon are also revealed, the movement of which is just as beguiling.

The Planetarium Tri-Axial Tourbillon is powered by the Calibre GP09310-0002 which is made up of about 386 interconnected components. The signature of this mechanism is the arrow-shaped bridges and a cage, both of which have been part of the brand's identity since the 1880s.

Like Ronaldo, who has been playing the 'Beautiful Game' professionally since 2002, Girard-Perregaux has never rested on its laurels; the Maison is always pushing itself with pieces like the Planetarium Tri-Axial Tourbillon. First introduced in 2014, GP added a 24-hour globe and Moon-phase display set in an aventurine dial in 2018. Ronaldo's customised watch is a variation of this version, with the same substantial 21.52 × 48mm-thick case forged from 18K rose gold, and a watch face and bracelet encrusted with baguette diamonds.

The value of this one-of-a-kind piece is estimated to be a cool $2 million.

# Arnold Schwarzenegger

"If you don't find the time, if you don't do the work, you don't get the results." —Arnold Schwarzenegger

THE RUNNING MAN

Opposite. Young Arnie in a gold Rolex GMT Ref. 1675 with a mocha-coloured dial (aka the 'Root Beer') – a watch that he still wears today.

Arnold Schwarzenegger has been many things in his life: body builder, actor, even governor of California. But mostly we know and love him for being Arnold Schwarzenegger.

Our favourite Arnie persona is as a watch collector. His horological interests are wide ranging, having been spotted wearing everything from Rolex to German brand Laco. Heck, he even launched his own (now defunct) brand in 2015.

Austrian-born, Schwarzenegger emerged into the public consciousness through body building. Through the 1960s and '70s, he was one of the most celebrated competitors in the history of the sport, winning titles such as Mr Universe and Mr Olympia. In this era, Schwarzenegger was frequently photographed wearing a gold Rolex GMT Ref. 1675 with a mocha-coloured dial (aka the 'Root Beer'). This timepiece is still a favourite, as proven by its appearance in the 2023 Netflix documentary *Arnold*.

Although he had been appearing in bit parts in the movies since the late 1960s, Schwarzenegger's career went stratospheric in the 1980s with starring roles in films such as *Conan the Barbarian* (1982), *The Terminator* (1984), *Predator* (1987), *The Running Man* (1987) and *Twins* (1988). This was the golden age of action movies and onscreen, Schwarzenegger was strongly associated with the rugged Seiko Prospex SNJ031, aka the 'Arnie'. Originally launched in 1975, the SNJ031 began life as a professional dive watch. Because some of us have trouble remembering reference numbers, enthusiasts gave it the nickname 'Tuna Can', or 'Tuna' for short, because the big case sat high on the wrist like a tin of prepacked fish.

Opposite. Arnold Schwarzenegger designed the first Audemars Piguet Royal Oak Offshore limited edition in 1999. We think he would approve of this blue ceramic Off Shore Automatique self-winding chronograph. Unveiled in April 2025, its blue-ceramic dial is inspired by the original 1972 model. Image courtesy of Audemars Piguet.

Page 112. The epic 'End of Days' Audemars Piguet Royal Oak Offshore self-winding chronograph from 1999. Image courtesy of Audemars Piguet.

Page 113. Another timepiece forever linked to Schwarzenegger: the Seiko Prospex SNJ031, aka the 'Arnie', worn in the films *Commando* (1985) and *Predator* (1987). Image courtesy of Seiko.

Over time, this distinctive diver added a digital display to its analogue dial. It was this generation of Tuna that was popularised by action-icon Arnold Schwarzenegger in movies like *Commando* (1985) and *The Running Man* (1987).

Just as Schwarzenegger was able to successfully cross over from body building, the actor was also able to toggle between cinematic genres, appearing in a string of 1990s comedies like *Kindergarten Cop* (1990), *Junior* (1994) and *True Lies* (1994). Likewise, the likeable star was just as influential selling luxury watches as he was popularising Seikos.

In an early example of celebrity-watch collaboration, Schwarzenegger partnered with Audemars Piguet in 1999 to create the first Royal Oak Offshore limited edition – the 'End of Days' Self-winding Chronograph. According to former AP CEO François-Henry Bennahmias, this endorsement "helped to put the collection on the map, especially in the street culture scene".

The Offshore is the bigger, bolder offshoot of the Royal Oak and Schwarzenegger's star power popularised the watch and oversized timepieces in general. Offshore watches are mainly sized at 42mm plus, and the vast majority are chronographs (making them look even larger on the wrist). They also tend to have a more avant-garde design sensibility, using materials like ceramic and rubber instead of precious metals.

In 2024, Schwarzenegger's admiration for AP landed him in hot water when customs officials in Germany detained him for three hours for failing to declare a one-of-a-kind version of the End of Days. The *Terminator* star was travelling to Vienna to auction off the luxury timepiece for the Schwarzenegger Climate Initiative at the Austrian World Summit but was flagged by customs officers for failure to complete the appropriate paperwork. The duty alone on the watch reportedly amounted to about €35,000. But the publicity around the event helped the watch sell for nearly three times its estimate, raising almost $300,000 (€270,000) for the organisation.

# Ed Sheeran

"My favourite thing in the world is to give people watches and see them turn into watch people." —Ed Sheeran

...IS ADDICTED

Opposite. At the Heart and Armor Foundation benefit concert in 2023 in Los Angeles, California, Sheeran and his friend John Mayer wore matching Audemars Piguet Royal Oak Concept Tourbillon 'Spiderman' watches.

Most people think of singer-songwriter Ed Sheeran as an everyday bloke. And while his signature look is a T-shirt, a pair of jeans and multiple tattoos, you will never see him without a watch on his wrist.

Because he is so relatable to his millions of fans, Ed's influence is a gateway to wearing a watch every day. But even the most hardcore Sheeran fans might be surprised that he has amassed a collection estimated to be worth over $6 million. The English pop star can always be seen sporting some of the world's most luxurious watch brands, including Patek Philippe, Rolex and Richard Mille. However, his collection has much more humble beginnings.

In an interview with the blog *Hodinkee*, Sheeran said his entry point into watch addiction was an inexpensive quartz ToyWatch timepiece. "It was pre signing my record deal. I hadn't made any money, I made about £500 doing a gig and a friend of mine had a ToyWatch and I always liked it because you could mix and match it with straps," said Sheeran. "I went out and I bought the watch, and I bought a green strap, a black strap, a white strap and an orange strap." Look at photos of Sheeran on his second tour and you'll see him wearing this ToyWatch. As Sheeran told *Hodinkee*, "I would cry if I lost this watch".

But Sheeran couldn't stop at just one watch. To commemorate the release of his first album + (as in, 'plus'), he bought a TAG Heuer Monaco. The collection quickly multiplied when, one month later, he bought a Hublot Big Bang. And just as there's a story behind every one of Sheeran's tattoos, there's a personal connection to every piece in Sheeran's watch wardrobe, too.

Above. The singer-songwriter's first collaboration with Casio, the G-SHOCK Ref. 6900 – Subtract By Ed Sheeran, was curated by his watch-collecting mentor John Mayer. Image courtesy of G-Shock.

Opposite. One of the perks of being a celebrity watch collector is getting to preview highly anticipated timepieces. Sheeran was spotted wearing this 42mm black ceramic IWC Ingenieur on *The Tonight Show Starring Jimmy Fallon* before its official launch at Watches and Wonders 2025. Image courtesy of IWC.

Page 118. One of Sheeran's favourite Richard Mille timepieces is the RM 38-01 Tourbillon G-Sensor Quartz TPT Bubba Watson. He has models in different colours and with the straps switched out. Image courtesy of Richard Mille.

Page 119. Sheeran bought this Hublot Skull Bang to celebrate his 21st birthday.

116

He likes to commemorate his travels with timepieces by local watchmakers. "One thing I love doing on tour is finding independent watch brands from the country I'm touring, and then wearing them for the duration of the tour in that country," he told *Hodinkee*. "JS Watch Company in Iceland, Sturmanskie in Russia, or a bigger brand like Lange in Germany. It gives me a buzz doing it and feels quietly like embracing a country in my own secret way."

The breadth and depth of Sheeran's ever-growing collection is also inspiring. At the higher end of the spectrum, there's the $825,000 Richard Mille RM 38-01 Tourbillon G-Sensor Bubba Watson Quartz TPT – an extremely limited showpiece that he wore to accept the Artist of the Year award at the VMAs in 2017. The RM 38-01 is one the most highly complicated manual-wound movements in the Richard Mille catalogue and would make any collector weep.

Though Sheeran is one of the most popular music acts of our time (selling more than 150 million records worldwide), he is also one of the most down-to-earth pop stars, proud to be just a guy from Framlingham in Suffolk, UK. This is why he collaborated with *Hodinkee* to make an affordable ($165) limited-edition G-Shock Ref. 6900 Subtract by Ed Sheeran. For the enthusiast, what could be better than getting the opportunity to design your own timepiece? The musician drew his inspiration for this bright-yellow, paint-splatted timepiece from his sixth studio album, – (as in, 'subtract') to make a watch that's fun, colourful, and very Ed Sheeran.

# Sylvester Stallone

"Looking at these watches, I feel truly lucky to have owned them; they serve as a reminder that hard work pays off." —Sylvester Stallone

### A PIECE OF THE ACTION

Above. In 2020, the Luminor 5218-201A worn by Sylvester Stallone in *Daylight* (1996) was sold at auction for $214,200. Image courtesy of Phillips.

Opposite. Stallone demonstrating his wrist flex on the German-language TV betting show *Wetten, dass...?* in 2008.

Sylvester Stallone is a watch-spotting legend. Since his early appearances in films like *Rocky* (1976), confirmed enthusiasts have kept an eye on the action star's wrists. But even the previously uncurious took notice when Sly stumbled across his first Panerai – a Luminor 5218-201A – while working in Rome.

At the time Stallone said, "I did a film called *Daylight*, and I wanted to wear a watch that no one had ever seen. I strapped this on my wrist that day and didn't take it off until the end of filming… This watch is a star".

The man nicknamed the 'Italian Stallion' soon became synonymous with the Italian Maison and vice versa. The partnership with Officine Panerai became official when the brand approached the actor about promoting the brand on- and off-camera.

Stallone first rose to prominence for writing, directing and starring in *Rocky*, a story about an underdog boxer. Panerai's history overlaps with this Cinderella tale in that it came from humble beginnings – it started out as a watchmaking school and repair shop that eventually expanded into developing serious tool watches for the Italian Royal Navy.

Panerai's most important discoveries were creating the luminous materials Radiomir and Luminor, which made the watches extremely readable in the field. But it also lent them a uniquely graphic look. Once Stallone started wearing Panerai watches, other action stars such as Arnold Schwarzenegger, Jason Statham and Dwayne 'The Rock' Johnson followed suit.

More recently, the star of the *Rambo* films (1982–2019) has been expanding his horological interests and has been seen sporting

Above. Stallone flying the flannel (and a Patek Philippe Nautilus Ref. 5980 Chronograph in rose gold) at the 2019 Cannes Film Festival.

Opposite. The ultimate survival watch, Stallone worked with Richard Mille to create the RM 25-01 Adventure tourbillon chronograph in 2018. Image courtesy of Richard Mille.

brands like Rolex, Audemars Piguet, Richard Mille and Patek Philippe on and off the red carpet. For example, in early October 2021, Stallone shocked those who were accustomed to seeing him wear only hockey puck-sized Panerais by posting a close-up of a relatively demure vintage Rolex GMT-Master 6542 with tropical dial on his official Instagram account. And in June of 2024, when auctioning off 11 of his timepieces at Sotheby's, Stallone flipped one of the holiest of grail watches – a Patek Philippe Grandmaster Chime 6300 from 2021, still in its original packaging.

With an image of rugged self-reliance, Stallone has starred in several fan-favourite, post-Apocalyptic flicks over the course of his career, from 1975's *Death Race 2000* to *Demolition Man* (1993) and the underrated *Judge Dredd* (1995). So, it was extremely fitting that Richard Mille would develop the RM 25-01 Adventure tourbillon chronograph in collaboration with the actor.

With this uber-complicated watch, Mille's stated goal was to create a luxury that could conquer the most hostile of natural environments. It has everything: a manual-winding timepiece with minutes, seconds, chronograph, 30-minute totaliser, and torque, it also has a mechanism that combines a tourbillon complication and the complexity of a new 'competition' chronograph movement. The lightweight titanium/carbon-composite case also houses a 70-hour power-reserve and an unusual 24-hour display that distinguishes between am and pm (should the viewer be deprived of sunlight).

# Taylor Swift

"Nothing is permanent. So I'm very careful to be grateful every second that I get to be doing this at this level."
—Taylor Swift

THE MIDNIGHT HOUR

There's no denying that Taylor Swift is one of the most watched women in Western culture. Since the American musician first appeared on the Country Music scene when she was 16, her impact on culture has been seismic. She has blurred the lines between musical genres, fought for artists' rights, and built a multi-generational community of fans that follow her from city to city, bringing an economic boost to each region that economists call 'The Taylor Effect'. Yet, for all her pop-cultural power, Swift has never been much of a watch influencer. That is, until 2024.

Sure, the mega star had watches. Swift's watch collection is rumoured to include a rose-gold Bulgari Serpenti, a Rolex Oyster Lady-Datejust Everose Gold Ref. 279381RBR, a rose-gold Cartier Tank Américaine Ref. W2620030, a stainless-steel Omega Constellation, a black-ceramic Chanel J12 Ref. H5699, and a Chopard Happy Sport Stainless Steel Rose Gold Ref. 278582-6001. These are all classics, and maybe that's why Swift's horological adventures weren't shaking up the watch world.

Then, at the 2024 Grammy Awards, Swift walked the red carpet wearing a vintage Concord set on a black diamond-studded Lorraine Schwartz necklace around her neck. The songwriter is known for seeding her liner notes with hidden messages to her fans, and for this event, Swift wore the watch set to 12am in reference to her album *Midnights* (2022).

This left-of-centre move prompted much media coverage of jewellery timepieces – an underappreciated section of the industry. But it was her next wrist move that converted the most snobbish watch spotters into Swifties. At an American football

Above. Swift frequently uses the snake emoji to send secret messages to her fans. She has also been seen with a Bulgari Serpenti wrapped around her wrist (like this turquoise-studded number worn by the author). Image Rhonda Riche.

Opposite. Taylor Swift arrives for the 66th Annual Grammy Awards wearing a Lorraine Schwartz choker with a Concord watch set to 12 o'clock in reference to her 2022 studio album *Midnights*.

This page. Swift counts in her collection the Chopard Happy Sport Ref. 278582-6001 in stainless steel and rose gold. Here's one of the most recent additions to the family – the Chopard Happy Sport Rose de Caroline. Image courtesy of Chopard.

Opposite. Swift was an early adopter of the 2024 revamp of the 40mm Louis Vuitton Tambour Automatic in yellow gold. Image courtesy of Louis Vuitton.

game between the Kansas City Chiefs and Denver Broncos, Swift was spotted in the stands cheering on her boyfriend Travis Kelce wearing a solid-gold Louis Vuitton Tambour.

Launched in 2023, the Tambour collection is part of Louis Vuitton's push to create haute-horlogerie pieces. The drum-like silhouette of this luxury sport watch itself takes its inspiration from an early LV watch line from 2002. Swift's version features an integrated bracelet, and a micro-rotor movement designed by La Fabrique du Temps – a manufacturer that designs and builds high-end movements for Louis Vuitton, Gérald Genta and Daniel Roth.

Just as Swift defies musical genres, the Tambour merges La Fabrique du Temps' technical excellence with Louis Vuitton fashion sense. Taylor's Tambour is set on a matching brushed-and-polished bracelet, and the dial design is a 21st-century take on the 'sector' design of Art Deco watches. The signature of this style is an outer minute ring with applied Arabic indices, set against an inner, vertically brushed section in a contrasting grey colour. This display also features a lumed and skeletonised handset, and a sub-seconds display above 6 o'clock.

Some have called the watch's old-school elegance 'grampa core'. But we say Swift knows the score.

# Tyler, The Creator

"I've seen some Rolexes, vintage ones, I really like, but aside from that, I'm just OK with the Cartiers. They bring me joy." —Tyler, The Creator

### THE ODD SQUAD

Opposite. Tyler, The Creator at the Soundset Music Festival, Minnesota, in 2014. He is wearing an LCD SpongeBob SquarePants watch that he bought as a tribute to his childhood timepiece.

Tyler Okonma is a professional chameleon. The two-time Grammy-winning artist, producer, director, composer and designer – best known as Tyler, The Creator – has broad and eclectic interests. In fact, what set his passion for collecting in motion was cars – Hot Wheels to be specific. He now owns much more super-charged super cars such as a Lancia Delta Integrale Evo II, a Rolls-Royce Cullinan, a BMW M3, a Fiat 131 Abarth Rally, and a McLaren 675LT.

Like the Hot Wheels, the rapper's current obsession for vintage, shaped Cartiers was informed by his childhood timepiece – a SpongeBob SquarePants watch from a Burger King kid's meal that he got when he was about 13. As he told the Robb Report in 2023, "I based a lot of my watch taste just off of how light it feels and how it could be colorful, too," he said. "It doesn't always have to be gold and iced-out."

Tyler first got our attention in the late 2000s, when the Californian teenager emerged as the leader and co-founder of Odd Future Wolf Gang Kill Them All (aka Odd Future) – an artistic collective that also featured Earl Sweatshirt and Frank Ocean. Within the group, Okonma worked as a rapper, producer, director and actor (performing on their sketch comedy show *Loiter Squad*).

Tyler Okonma is also known for creating personas for his various projects. He directs his own videos under the pseudonym Wolf Haley, and on his most recent record *Chromakopia* (2024) he refers to himself as 'T' and wears a mask on the album's cover.

The polymath's current Cartier collection includes a Baguette Or Coulissant, a Santos-Dumont, a Baignoire, a Must de Cartier Tank, a Crash, an enamelled bezelled Obus, a Petit Cylindre and

a Tank Louis Cartier. Before the Cartiers, however, Tyler almost exclusively sported a Casio MQ24-9B, a $23 black-resin watch with a beige dial, a 24-hour track, and a quartz movement.

For a code shifter like Tyler, this minimalist Casio is the ultimate flex – the scored resin strap is designed for maximum flexibility. The hands are needle-thin black sticks that don't fight the dial or case for attention. The MQ24-9B's sans-serif font reads very Eighties. And because the numerals are a mix of mini and oversized, it lends the display an eccentric pattern – they do not look like a perfect circle. All in all, the MQ24-9B is as instantly recognisable as a Cartier Crash or Tank Française.

The analog MQ24 series, which debuted in 1987 (four years before Tyler was born), also suits Tyler's sense of levity. It measures in at 38.8 × 34.9 × 7.8mm and weighs 20g. It's tough, too: water resistant with a resin glass crystal. Casio recently updated the operating module so it's even more dependable with an accuracy of plus/minus 20 seconds per month. And best of all, you can still walk into most department stores and pick one up for a song!

This page. The Casio MQ24-9B that Tyler favoured before he began his Cartier collection; an inexpensive timepiece with an enduring appeal. Image courtesy of Casio.

Left. Even after venturing into high-end horology, Tyler, The Creator likes to keep it quirky. The Cartier Obus takes the silhouette of a Tank Chinoise or Française but with a bigger bezel and pill-shaped lugs. Image courtesy of Cartier.

Right. The unusual shape of the Cartier Pebble was born in the Swinging Sixties and revamped in 2022. Image courtesy of Cartier.

# Andy Warhol

"They always say time changes things, but you actually have to change them yourself." —Andy Warhol

THE ART OF WATCHES

Opposite. Andy Warhol in repose in 1981.

Andy Warhol was the Pope of Pop Culture. His sensibility redefined what art meant in the post-expressionist era. He predicted our influencer-obsessed culture, and he was a collector extraordinaire.

During what has been described as an obsessive shopping spree that lasted decades, Warhol amassed 175 cookie jars, 313 watches, 57 Navajo blankets, 210 Bakelite bracelets, 1,659 pieces of Russel Wright pottery and 170 chairs, among other objects.

Warhol was also well-known as a watch lover. When his estate was inventoried for the storied Andy Warhol Collection, Jewelry and Watches, Part II auction at Sotheby's New York in 1988, the auctioneers counted 313 timepieces. The lots included a wide variety of makes and models, from Movados to a plastic Fred Flintstone quartz watch.

Just as he did in his art practice, Warhol's watch collection mixed the high with the low. Alongside Fred Flintstone, the auction listed almost 100 watches from Patek Philippe, Rolex, Cartier, and other luxury watchmakers. In fact, Warhol assembled a quite canny collection of important calibres. Among the highlights of that legendary 1988 auction (also known in the trade as Andy Warhol's Stuff) were a rectangular Patek Philippe Ref. 2503 from 1952 and a Patek Philippe Ref. 2526 – the manufacturer's first automatic wristwatch.

Other pieces of note included a Cartier Tank Cintrée that was purchased by Ralph Lauren, who later said, "I loved this great gold cuff on one piece. The watch it was attached to was nothing, but I purchased it and had the gold cuff sized to my wrist and put on this [the Cintrée]. It is one of my favorite watches. The combination

Opposite. The artist's rare Rolex Reference 3525 chronograph, photographed at a preview for the Christie's 'Rare Watches' auction in 2019. Image Rhonda Riche.

is unique, and such a personal expression of a one-of-a-kind heirloom timepiece".

So, while Warhol knew a good watch when he saw one, he didn't collect them for horological significance or their resale value. Rather he collected them like he did his celebrity friends: for their cachet.

Warhol was famously quoted as having said "I don't wear a [Cartier] Tank watch to tell the time. In fact, I never wind it. I wear a Tank because it's the watch to wear". That's because Warhol was a bit of a hoarder. He kept most of his stuff in his townhouse at 57 E. 66th Street. It has been whispered that the artist kept his favourite watches at the centre of the canopy that hung over his bed. And, while preparing for the Andy Warhol Collection, Part I, two curators who were going through the artist's archival material discovered a secret stash of jewellery and watches hidden between two filing cabinets. Hence the second sale – Part II.

Above. The Black Tie was Warhol's favourite watch in the 1980s. In 2024, Piaget honoured the artist by renaming this model the 'Andy Warhol'. Image courtesy of Piaget.

Opposite. The pop-art icon wearing his signature 1970s watch – a Cartier Tank.

Within his massive watch collection was a subcollection of timepieces by luxury Maison Piaget. Warhol purchased seven Piaget watches, but the edition most associated with the artist is an ultra-thin, quartz-powered, yellow-gold Black Tie model with an anthracite-grey galvanic dial.

Warhol was so enamoured with Piaget, that he became a full-fledged member of the Piaget Society, travelling with Yves Piaget to events held in New York and Palm Beach, and joining him for outings to such storied nightspots as Studio 54 or Chez Régine. In 1983, Warhol even featured his friend in *Interview* magazine.

Today, celebrities such as Michael B. Jordan and The Weeknd are pushing a Piaget resurgence, partially driven by Warhol's association with the Black Tie and the Polo. Four of his timepieces are now kept in Piaget's private collection (presumably in a safe and not stashed between filing cabinets). Over the years, the maison has paid homage to its loyal client with reissues of the Black Tie, which is now available in made-to-order styles with hardstone dials.

# Pharrell Williams

"You sort of have to become what you're wearing."
—Pharrell Williams

THE ULTIMATE WATCH N.E.R.D.

Opposite. Pharrell Williams representing the Richard Mille RM UP-01 Ferrari at the 2024 Olympics in Paris.

Celebrities and fashion go together. When fashion week takes over a city, the stars we see seated in the front row are an essential part of a brand's marketing strategy – sometimes generating more buzz than the new collection itself. The fame game also applies to watchmaking as well. Pharrell Williams, the American musician and producer, took celebrity to the next level when he became the creative director for Louis Vuitton menswear in 2023. The announcement (via Instagram) of Williams' appointment came about 16 months after the sudden death of the fashion brand's previous director Virgil Abloh. In the post, LVMH stated that "[Williams] is a visionary whose creative universes expand from music to art, and to fashion—establishing himself as a cultural global icon".

Williams has always had a passion for fashion (he founded the streetwear label Billionaire Boys Club and has also designed for Adidas and Chanel), but he is also a well-known watch enthusiast.

A true polymath, Pharrell Lanscilo Williams, along with his musical partner Chad Hugo, showed his first flashes of genius as part of the production duo The Neptunes in the 1990s. One of the team's most famous tracks was 1999's 'Caught Out There' by Kelis. Williams was a horological trailblazer at the time, appearing at the end of the video wearing a bold gold watch, and championing the Audemars Piguet Royal Oak way before most sports stars and musicians. One of the most notable models in Williams' collection from this era was the skeletonised Perpetual Calendar Ref. 25636. Williams had two of these ultra-rare models, one in gold and one in platinum (one of which is now owned by Frank Ocean).

Opposite. Williams' innate sense of style makes him one of the most influential watch collectors. Here, his love of all things extra-terrestrial has informed the design of the RM 52-05 Manual Winding Tourbillon Pharrell Williams. Image courtesy of Richard Mille.

Williams' sartorial style samples from many genres. The eternally youthful musician has been photographed wearing everything from strands of Chanel pearls to minimalist Japanese street styles. That's why it should be no surprise that his collection includes a flashy, factory-set Chopard Imperiale, pavé-set with radiating baguette diamonds on the dial and bezel.

Williams' collection is best defined by his devotion to Richard Mille. A short list of his RMs includes the RM 031 High Performance, the RM 70-01 Alain Prost and the RM 52-05 Pharrell Williams.

One of his most recent Richard Mille acquisitions is the super thin (1.75mm to be exact) Richard Mille RM UP-01 Ferrari – a watch that looks more like a futuristic hotel room card than a conventional watch. At the 2024 Louis Vuitton Fall/Winter runway presentation, the designer paired the watch with a cowboy-inspired look from his collection.

He also has a deep affinity for intergalactic themes, even naming his now-defunct record label Star Trak. His most out-of-this-world timepiece is his RM 52-05 Manual Winding Tourbillon Pharrell Williams. The spacey look of this limited edition of

30 pieces, manual-winding, tourbillon movement with hours and minutes, feels very Pharrell. His artistic output has always been about shifting perspectives in unexpected ways. "If it's not subversive, it's just plain," says Williams. "We need things to 'pop' in this world. As humans, we spend our time looking out at the cosmos. The 'pop' on the RM 52-05 comes from totally changing our perspective a full 180°. It's the moment we realise, staring at the watch's face, that what we are peering at, through the vastness of space is…ourselves."

The RM 52-05 Manual Winding Tourbillon Pharrell Williams also pushes the boundaries of watch architecture. The innovations of the helmet-shaped timepiece include a grade 5 titanium baseplate and bridges that reveal blue aventurine glass inserts. The case is constructed of brown cermet, which combines the lightness of titanium with the hardness of a ceramic. The case band is made of Carbon TPT, which is mostly used in the aerospace industry. And it's a high-precision tourbillon – historically one of watchmaking's most complicated mechanisms.

One of those rare talents that combines style and substance, our man Williams' taste in timepieces certainly reflects the multiverse he lives in.

Opposite. Pharrell Williams at the Global Citizen Festival in 2017 at Barclaycard Arena in Hamburg, Germany, matching his Louis Vuitton T-shirt with his Richard Mille UP-01 Ferrari.

# Serena Williams

"*I sounded different.* I dressed differently. I served differently. But when I stepped onto the court, I could compete with anyone." —Serena Williams

**MATCH, SET, LOVE**

Opposite. Williams at the 2024 Vanity Fair Oscar party wearing an Audemars Piguet Royal Oak 'Jumbo' Extra-Thin Openworked 16204BC in 18K white gold.

One of the greatest tennis players ever to grace the courts, Michigan-born Serena Williams not only mastered the athletic intricacies of the game (she won 23 Grand Slam women's singles titles and is the only player to accomplish a career Grand Slam in both singles and doubles) AND she did it while serving looks.

Before Williams, athletes didn't have many opportunities to express themselves while performing. Tennis clubs had unspoken and spoken dress codes, and the aesthetic of the sport had evolved into a uniform of flouncy white skirts and double-knit polo shirts. But Williams brought a new kind of confidence to the court. Sometimes the clothes she wore were controversial (take for example her denim skirt and boots from 2004, itself a reference to the tiny jean shorts Andre Agassi competed in at the 1988 US Open).

Over the course of her lengthy career, Williams went from being a fashion iconoclast to a designer muse – before the 2024 Paris Olympics, she walked the runway for Louis Vuitton. Now fashion has become part of the game (Naomi Osaka wore a gothic Lolita outfit designed by designer Yoon Ahn for Nike to the US Open in 2024).

Yet Williams has always remained true to herself and loyal to family and friends. One of the most enduring associations is with the luxury watchmakers Audemars Piguet and their iconic sport-chic watches, the Royal Oak. There are a couple of reasons that this partnership is important. First off, the Royal Oak has a lot of wrist presence. And Williams is known to wear the larger sizes of this chunk of funk. Not only was she ahead of the curve of the women-wearing 'boyfriend watch' movement, but she was also wearing them on and off the court.

Above. Williams at the 2024 Espy Awards, where she changed into eight different outfits and almost as many Royal Oaks.

Opposite. Williams in 2022 at the AP Royal Oak book launch where she was presented with a Royal Oak 'Jumbo' Extra Thin 50th anniversary watch, engraved with 'Serena Williams' and 'GOAT' on the back. Image courtesy of Audemars Piguet.

Let's break this down. It wasn't so long ago that women didn't wear watches to a formal event (a proper lady was not supposed to concern herself with trivialities such as time at fancy functions), but Williams wore a Royal Oak to the Met Gala. And athletes did not wear watches in competition because every extra ounce of weight on the wrist could affect performance, yet Williams took many trophies with an RO strapped to her wrist.

The relationship has also been fruitful for AP. Appearing on a Wheaties cereal box means that an athlete has arrived as a sports legend. When Williams reached that status, she was illustrated wearing a Royal Oak. And what better advertisement for the

This page and opposite. As an Audemars Piguet brand ambassador, Williams has probably worn every Royal Oak on the market. But when she brought this Double Balance Wheel Openwork to Paris for the 2024 Olympic games, the horological heads collectively dropped their jaws. The Ref. 15407ST is stunning because its skeletonised cal. 3132 allows the viewer to truly appreciate a watchmaker at the top of their game – the horological equivalent of seeing Williams dominate the court. Images courtesy of Audemars Piguet.

durability and performance of a timepiece than one that could handle the physical force of a hit from Williams' serve?

The new Code 11.59 by Audemars Piguet also embodies the sheer force of Williams' personality. There are 1,085 precious stones (4.99 carats) adorning the dial, and the architectural case, lugs and fluted crown of this 41mm timepiece are available in 18K white or pink gold. Around the periphery of the dial, the inner bezel displays a graduated, five-by-five minute scale. Like Williams at the top of her game, this refined timepiece flashes with brilliance with every movement.

# Michelle Yeoh

"The first present I ever received from my dad was a watch. And then the first significant thing I ever bought myself was a watch." —Michelle Yeoh

THE LEGEND

Opposite. Michelle Yeoh lights up the red carpet of the Red Sea Film Festival 2024 wearing a red-gold RM 07-01 with an open bracelet set with pavé diamonds.

Michelle Yeoh has been kicking down doors for women (and Asian actors and women of a certain age) for decades. The Malaysian-born actress has been everything from a Bond girl in *Tomorrow Never Dies* (1997) to a martial legend in the epic *Crouching Tiger, Hidden Dragon* (2000), with her superstar status in Asia translating into Western success in 2018 with films such as the blockbuster *Crazy Rich Asians*. And at age 60, she won multiple awards for the role of Evelyn Quan Wang in the surreal *Everything Everywhere All at Once* in 2022.

With an excellent eye for bold timepieces, Yeoh is also an important role model for women who love great watches. For example, when she married former FIA president and Scuderia Ferrari Formula 1 team boss Jean Todt in 2023, she sported a stunning but sporty Patek Philippe Aquanaut Luce 'Rainbow'. In doing so, Yeoh challenged conventional dress codes that claimed women shouldn't wear wristwatches with formal attire, and if they did, the timepieces in question should be teeny tiny and demure.

Just as Yeoh has crossed over into many cinematic genres – from sweeping epics to rom-com – this bedazzling watch blurs the line between sport and jewellery watch. It features an outer bezel set with 40 exquisite 'Rainbow' style sapphires, and an inner bezel set with 40 diamonds. If that's not quite enough precious stones for your tastes, the dial is also decorated with 12 more 'Rainbow' style sapphires as hour markers.

Not only is Yeoh reshaping the role of the watch on the red carpet (and weddings), but she is also something of a muse for Richard Mille. Two models – the RM 051 and RM 51-01 Tourbillon –

Above. The rectangular Titalyt-treated grade 5 titanium RM 016 Extra Flat is a different look for Richard Mille, but Yeoh manages to make it her own.

Opposite. Longtime Richard Mille ambassador Yeoh was honoured with the RM 51-01 Tourbillon Michelle Yeoh in 2014. Image courtesy of Richard Mille.

are almost synonymous with the actress. She was introduced to the brand by Todt, who as the former director of Scuderia Ferrari had a partnership with Richard Mille. Yeoh was already into oversized, masculine watches: "For me, it is a statement," she said in a press release for Richard Mille. "A watch isn't just about telling the time. I don't agree that women should only wear small watches."

This philosophy fits perfectly with Richard Mille's bold yet elegant aesthetic. The brand's tonneau shape demands attention, while the intricate dial details add brilliance. The watchmakers and the movie star first collaborated in 2011 on the RM 051 Tourbillon Michelle Yeoh. This limited-edition jewellery watch was decorated with a symbolic diamond-covered phoenix but the Calibre RM051 manual-winding tourbillon movement with hours, minutes and power-reserve indicator also packed a serious horological punch.

Since then, Yeoh has appeared on hundreds of red carpets accessorising a Mille with gorgeous couture gowns. Many of these timepieces are unique. At the 2018 Los Angeles premiere of *Crazy Rich Asians,* Yeoh paired a bespoke RM 19-02 Tourbillon Fleur with an Armani Privé gown and Bvlgari diamonds. This floral-themed watch features an automaton mechanism with enamel petals that

This page. Yeoh relaxing with a rose-gold Richard Mille RM 07-01 with a medium-set diamond jasper dial. Image courtesy of Richard Mille.

Opposite. For her wedding to racing executive Jean Todt, Yeoh said "I do" wearing a Patek Philippe Aquanaut Luce Rainbow. The watch, which debuted at Watches and Wonders in 2023, features a full spectrum of sapphires around the outer bezel and 40 dazzling diamonds lining the inner bezel. Image courtesy of Patek Philippe.

bloom every five minutes to reveal a flying tourbillon. The white-gold diamond-set watch was created as a 33-piece limited edition, but Yeoh's version was set with additional rubies.

The reason Richard Mille resonates with Yeoh's fans is that, just like her onscreen characters contain different layers and motivations, the technical and design elements of her watches feel like they are in an ongoing conversation with themselves. Their complications make them compelling.

# Index

Page numbers in **bold** indicate illustrations

**GENERAL**

12 Hours of Sebring 82, 85
24 Hours of Daytona 94
24 Hours of Le Mans 62, 82, 85

A$AP Rocky 103
Abloh, Virgil 138
Academy Museum of Motion Pictures 94
Adidas 138
Agassi, Andre 144
Ahn, Yoon 144
Al Nassr 104
Alltounian, Haig 85
Anderson, Jonathan 41
Andy Warhol Collection, Jewelry and Watches, Part II auction 132, 135
Apatow, Judd 54
Apple iPod 69
Armani Privé 153
Art Deco 127
Artist of the Year award 116
Austrian World Summit 111

Ballon d'Ors 86
Basquiat, Jean-Michel 101
BBC Radio 2 76
Beatles, The 12
Beckham, David **8, 11**; 9–10, 12, 15
Beckham, Victoria **8, 13**; 9, 12, 15
Bennahmias, François-Henry 111
Beyoncé 67
Billionaire Boys Club 138
Bling Ring 18
Bloom, Orlando **16**; 17–18
Blount, Will 44
Bodiratnangkura, Patcharavipa 103
Bond girl 150
Brando, Marlon **20, 23**; 6, 20, 23
British Fashion Awards 15
Bulgari 153
Buñuel, Luis 24

Carey, Mariah 67
Carter, Shawn Corey *see* Jay-Z
Cartier, Louis 24
Casio PT-1 keyboard 79
Chanel 24, 138, 140
Chanel No. 5 24
Charles, Prince of Wales 30, 32
Chez Régine 136
Christie's 73–4
Chrono24 104
Clapton, Eric 76
CNBC 62
Colbert, Stephen 57, 59
Coldplay 41
Combs, Luke 79
Comedic Genius Award 54
Copa América 86
Coppola, Sofia 18
Corleone, Don Vito 20
CR7 (brand) 104

Def Jam Recordings 67
Demy, Jacques 24
Deneuve, Catherine **25, 28–29**; 24, 27
Denver Broncos 127

Diana, Princess of Wales **31–32**; 7, 30, 32
Downey Jr, Robert **35–36**; 34, 36
Driver 44
Duchess of Sussex, The (*see* Meghan Markle)
Duke of Sussex, The (*see* Prince Harry)

Earl Sweatshirt 129
Elizabeth II, Queen of England 30
Elton John AIDS Foundation 74
Emanuel, David and Elizabeth 30
English, Giles and Nick 17
Espy Awards 146
Evans, Chris 44

Federer, Roger **38, 42–43**; 39, 41
Fenty, Robyn Rihanna *see* Rihanna
Ferrari 50
Forbes 100
Formula One 49
French Open 39
Fuller, Simon 12
Funds for Cinema 27
Furnish, David 73

Gabor, Zsa Zsa 20
Geneva Watch Auction 27
Genta, Gérald 97, 99, 127
German Air Force 49
Gerwig, Greta 44
Global Citizen Festival 142
Golden Globes 34
Gosling, Ryan 44
Grammy Awards 107, 125, 129
Grand Prix d'Horlogerie de Genève 76
Grand Slam 39, 144

Hamilton, Lewis **48, 51–53**; 49–50
Haring, Keith 101
Harry, Prince (also, Duke of Sussex, The) **31**
Hart, Kevin **55, 58–59**; 54, 57, 59
Heart and Armor Foundation 79, 114
Heuer, Jack 82, 85
Hilton, Paris 18
*Hodinkee* blog 7, 76, 79, 114, 116
Hollywood Walk of Fame 12
Hugo, Chad 138

Iglesias, Enrique 104
'Important Watches Auction' (Sotheby's) 92
Indy 500 team 85
Inter-Miami CF 9–10, 86, 89
Iron Man 34
Italian Royal Navy 121

James, Bronny 60
James, LeBron **61**; 60, 62
Jay-Z (also, Shawn Corey Carter) **66, 70**; 7, 67, 69, 71, 73
John, Elton 73
Johnson, Dwayne 'The Rock' 121
Jones, Grace 101
Jordan, Michael B. 136
JW Automotive Engineering 82

Kansas City Chiefs 127
Kardashian, Kim 73
Kelce, Travis 127
Kelis 138
Ken 44, 47
Kern, Georges 15
Keys, Alicia 67
King of England 30
Kurtz, Colonel 20

L.A. Lakers 60
L'Oréal 27
La Fabrique du Temps 127
La Fondazione La Biennale di Venezia 27
Las Vegas Grand Prix 103
Lauren, Ralph 132
Laver Cup 41
Leitch, David 47
Loewe 41, 103
Lohan, Lindsay 18
Louis Vuitton (brand) 27, 103, 138, 140, 142, 144

MAC 27
Madonna 44
Malek, Rami 27
Mancini, Roberto 54
Marianne 24
Mark Twain Prize for American Humor 59
Markle, Meghan (also, Duchess of Sussex, The) 32
Matsoukas, Melina 101
Mayer, John **77, 79–80**; 7, 76, 79, 114, 116
McLaren (racing team) 85
McQueen, Steve **83, 85**; 82, 85
Mercedes-AMG Petronas (racing team) 49–50, 99
Messi, Lionel **87, 89**; 86, 89
Met Gala 41, 146
Miami Grand Prix 49
MTV Movie Awards 54
Mustang P-51K-10 (aeroplane) 7–18

Nadal, Rafael 104
Neptunes, The 138
New Wave 24
Newman, Paul **91, 95**; 6, 90, 92, 94
Nike 104, 144

Ocean, Frank 129, 138
Odd Future Wolf Gang Kill Them All (aka Odd Future) 129
Okonma, Tyler *see* Tyler, The Creator
Osaka, Naomi 144
Oscar (award) 20, 34, 99

Paris Olympics 38, 144, 148
'Passion for Time – An Important Private Collection of Watches and Timepieces' auction 3
Pestana 100
Piaget, Yves 136
Pitt, Brad **96**; 6, 97, 99
Polanski, Roman 24

Quan Wang, Evelyn 150

'Rare Watches' auction (Christie's) 35
Real Madrid 104
Red Rocks Amphitheatre 81
Red Sea Film Festival 50
Refn, Nicolas Winding 44
Rihanna **100**; 7, 67, 101, 103
Robbie, Margot 44
Roc-A-Fella Records 67
Roger Federer Foundation 41
Rolex Testimonee 39
Ronaldo, Cristiano **105**; 104, 107
Roth, Daniel 127
Rugby World Cup 41
Russel Wright (pottery) 132
Russell, George 49
Ryan, Rusty 97

Saint Laurent, Yves 24, 27
Salamon 103
Schumacher, Michael 67
Schwartz, Lorraine 103, 125
Schwarzenegger Climate Initiative 111
Schwarzenegger, Arnold **109**; 108, 111, 121
Scott, Travis 69
Scuderia Ferrari (racing team) 150, 153
Seavers, Colt 47
Seinfeld, Jerry 97
Sheeran, Ed **115–16, 119**; 7, 76, 114, 116
Sir Elton John: Goodbye Peachtree Road auction (Christie's) 3–74
Snyder, Tom 73
Sotheby's 85, 92, 122, 132
Soundset Music Festival 129
Spencer, Diana *see* Diana, Princess of Wales
Spencer, John; 8th Earl Spencer 32
Spice Girls 12, 15
SpongeBob SquarePants LCD watch **128**; 129
Statham, Jason 121
Stallone, Sylvester **120, 122**; 121–22
Star Trak (record label) 140
Stern, Thierry 62
Strauss, Lewis 34
Studio 54 136
Super Bowl LVII 103
Swift, Taylor **124**; 103, 125, 127
Swinging Sixties 24, 131

Tarantino, Quentin 97
Tiffany & Co. 62
Todt, Jean 150, 153–54
Truffaut, François 24
Tyler, The Creator (also, Tyler Okonma) **128**; 129–30

UNICEF Goodwill Ambassador 9
Uniqlo 41
US Open 144

Vanity Fair Oscar party 144
Venice Biennale 27
Victoria Beckham Beauty 15

vintage 6–7, 17, 44, 59, 79, 90, 92, 97, 107, 122, 125, 129
VMAs 116

Warhol, Andy **133, 137**; 132, 135–36
Warm & Wonderful (brand) 30
Watches and Wonders (trade show) 32, 116
*Watchonista* blog 99
Watkins Glen 90
Weeknd, The 136
Weston, Bevan 85
Whiley, Jo 76
William, Prince of Wales 32
Williams, Pharrell **139, 143**; 97, 103, 138, 140, 142
Williams, Serena **145–47**; 144, 146, 148
Wimbledon (Championships) 39, 42
'WINNING ICONS - Legendary Watches of the 20th Century' auction (Phillips) 94
Wolf Haley 129
Woodward, Joanne 92
World War II 17, 18, 82

Yeager, Chuck 67
Yeoh, Michelle **151, 153–54**; 7, 150, 153–54

Zela (restaurant) 104

**WATCH BRANDS**

**Asprey** 30

**Audemars Piguet** 7, 32, 34, 54, 59–62, 69, 71, 76, 79, 81, 86, 111, 122, 144, 146–48
Code 11.59 148
Grande Sonnerie (vintage) 59
Royal Oak **59 146**; 62, 79, 99, 111, 138, 144, 146, 148
Royal Oak 'Jumbo' Extra-Thin Openworked 16204BC **145, 147**
Royal Oak Chronograph Leo Messi **86, 88**; 86
Royal Oak Concept 97
Royal Oak Concept Tourbillon 'Spiderman' **79, 114**
Royal Oak Double Balance Wheel Openwork Ref. 15407ST **148–49**
Royal Oak Offshore 111
Royal Oak Offshore 'End of Days' **112**; 111
Royal Oak Offshore Automatique 111
Royal Oak Offshore Jay-Z 10th Anniversary limited edition 69
Royal Oak Offshore LeBron James limited edition **61**; 62
Royal Oak Perpetual Calendar John Mayer **81**; 79
Royal Oak Perpetual Calendar Openworked 'Cactus Jack' 69
Royal Oak Perpetual Calendar Openworked Ceramic Ref. 26585CE **70**
Royal Oak Perpetual Calendar Ref. 25636 138
Royal Oak Self-Winding Flying Tourbillon Extra-Thin RD#3 59

**Benrus** 3061 **85**; 82

**Breitling** 15, 97, 99
Chronomat Automatic 36 15
Chronomat Automatic 36 Victoria Beckham **14**; 15
Navitimer 97
Premier B01 Chronograph 42
Norton AB0118A21B1A1 **96**

**Bremont** 17 18
Limited Edition P-51 **19**; 17, 18

**Bulgari**
Serpenti **125**; 125

**Cartier** 7, 24, 27, 32, 73, 101, 103, 129–30, 132
Baguette Or Coulissant 129
Baignoire **29**; 24, 27, 129
Crash **73**; 73, 130
Obus **131**; 130
Pebble **131**
Petit Cylindre 130
Santos 73
Santos-Dumont 129
Tank **137**; 135
Tank Américaine Ref. W2620030 125
Tank Chinoise 131
Tank Cintrée 132
Tank Française **26**; 12, 27, 32, 130–31
Tank Louis Cartier **32–33**; 32, 130
Tank Must (also Must de Cartier) 24, 129

**Casio** 7, 107
G-Shock Ref. 6900 by John Mayer 79
G-Shock 7, 76, 79, 101
G-Shock Baby-G 101
G-Shock Ref. 6900 Subtract by Ed Sheeran **116**; 116
G-Shock Ref. 6900-PT1 by John Mayer **78**
G-Shock Ref. 6900-PT80 by John Mayer 79
MQ24-9B **130**; 130

**Chanel**
J12 Ref. H5699 125

**Chopard** 75
Happy Sport Ref. 278582-6001 125, 127
Happy Sport Rose de Caroline **127**
Imperiale 74, 140
L'Heure du Diamant **100**; 101

**Citizen**
8110A 97

**Concord 124**; 103, 125

**Franck Muller** 7, 73
Vanguard Chronograph **72**

**Girard-Perregaux** 107
Planetarium Tri-Axial Tourbillon 104, 107

**Greubel Forsey**
GMT Tourbillon **35**

**Hanhart**
417 ES Chronograph 82

**Heuer** 47, 82
Carrera 2447 NS 47
Monaco Gulf **82–84**; 82, 85

**Hublot** 69, 71
Big Bang 114
Shawn Carter Classic Fusion **68–69**; 71
Skull Bang **116**

**IWC** 18, 49–50
Big Pilot 49–50
Big Pilot Ref. 5002 76
GST Chronograph 76
Ingenieur **117**; 99
Ingenieur SL Ref. 1832 **98**; 99
Pilot's TOP GUN 'Mojave Desert' **53**; 49–50
Pilot's Watch Chronograph 41 Edition 'Mercedes-AMG PETRONAS Formula One™ Team' 50
Portugieser Tourbillon Rétrograde Chronograph Lewis Hamilton **48–49**; 50

**Jacob & Co.** 86, 89, 103
Brilliant Skeleton Northern Lights **102**; 103
Caviar Tourbillon 107
CR7 Epic X **106**; 104, 107
CR7 Epic X 'Heart of Cry' **107**; 107
Epic X Chrono Messi **87**; 86

**Jaeger-LeCoultre** 24, 27, 34, 71
Joaillerie 101 Etrier 27
Master Control Automatic Triple Calendar **74**; 74
Polaris 34
Reverso 'Grande Automatique' Ref. 3038420 27
Reverso Tribute Chronograph **36–37**; 34, 36

**JS Watch Company** 116

**Laco** 108

**Louis Vuitton** 127
Tambour **126**; 127

**Movado** 132

**Officine Panerai** 121–22
Luminor 5218-201A **121**; 121

**Omega**
'Pie Pan' Constellation 99
Constellation 101
Seamaster 300 (1957 edition) 20

**Patek Philippe** 7, 10, 24, 27, 32, 34, 44, 54, 60, 62, 101, 114, 122, 132
Aquanaut Luce 'Rainbow' **155**; 150, 154

Calatrava Ref. 3618 **31**; 30
Disco Volante 30
Flyback Chronograph Ref. 5905R 'Blue' **89**
Grand Complications Celestial 9
Grandmaster Chime 6300 122
Nautilus 99
Nautilus Ref. 3700 99
Nautilus Ref. 3800/1J 99
Nautilus Ref. 5711 Tiffany **63**; 62
Nautilus Ref. 5980 Chronograph **122**
Nautilus Ref. 7118 / 1A-001 15
Ref. 2503 132
Ref. 2526 132
Ref. 6102R Celestial **55**

**Piaget** 101, 136
Black Tie **136**; 136
Polo 103, 136
Polo Date Rainbow **103**
Polo New Style 101, 136

**Richard Mille** 7, 50, 60, 114, 116, 122, 140, 150, 153–54
RM 031 High Performance 140
RM 051 Tourbillon Michelle Yeoh 150, 153
RM 056 Blue Sapphire 'BluePrint' **66**; 69
RM 07-01 **150, 154**
RM 07-01 **150, 154**
RM 11-01 Robert Mancini **56**; 54
RM 19-02 Tourbillon Fleur 153
RM 25-01 Adventure Tourbillon Chronograph **123**; 122
RM 38-01 Tourbillon G-Sensor Bubba Watson Quartz TPT **118**; 116
RM 51-01 Tourbillon 150
RM 51-01 Tourbillon Michelle Yeoh **152**
RM 52-05 Pharrell Williams **141**; 140, 142
RM 67-02 'Italy' **50**; 50
RM 70-01 Alain Prost 140
RM UP-01 Ferrari **139, 143**; 140

**Rolex** 6, 15, 17–18, 20, 34, 39, 41, 54, 59, 67, 71, 90, 94, 101, 108, 114, 122, 132
Air-King 41
Datejust 15, 20, 92
Datejust (1973 edition) 20
Day-Date 60, 90, 97
Day-Date 118238GLWAFO **58**
Day-Date II **43**; 39
Daytona **15, 75, 94–95**; 7, 15, 54, 74, 90, 92, 94
Daytona 'Zenith' **92–93**; 94
Daytona Ref. 3236 Big Red 92
Daytona Ref. 6239 (also, Daytona 'Paul Newman') 90, 92, 94
Everose Cosmograph Daytona **13, 15**
Explorer II 76
Explorer II Ref. 1655 17
Explorer Ref. 1016 'Kermit' Submariner **16**; 17
GMT-Master 'Pepsi' Ref. 1675 17
GMT-Master II 41
GMT-Master II 'Batman' **77**

157

GMT-Master Ref. 1675 **21–23, 109**; 20, 23, 108
GMT-Master Ref. 6542 122
Hulk Supercase LV Submariner **80**
King Midas 103
Milgauss Ref. 6543 17
Oyster Lady-Datejust Everose Gold Ref. 279381RBR 125
Oyster Perpetual 60
Oyster Perpetual Air-King **40–41**
Oyster Perpetual Day-Date 'Puzzle Watch' **64–65**; 60
Ref. 3525 Chronograph **134**
Sky-Dweller 326934 GMT **38**; 39
Speedking 82
Submariner 90
Submariner 'Kermit' 17
Submariner Ref. 5512 82
Submariner Ref. 6538 'James Bond' 17
Yacht-Master **12**; 12
Yacht-Master II 39

**Seiko** 6, 111
Prospex SNJ031 **113**; 108

**Sturmanskie** 116

**Swatch** 107
Swatch: MoonSwatch 7

**TAG** 47, 82

**TAG Heuer** 6, 44, 67, 85
Carrera Chronograph CBS2210.FC6534 **46–47**; 47
Carrera Chronograph Gold **44**; 44
Carrera Ref. 110.515 44, 47
Carrera Ref. 1158 CHN 44, 47
Carrera Ref. 2448 44
Grand Carrera Calibre 17 **51**
Kirium WL1113 6
Monaco 114

**Time Force Watches** 104

**ToyWatch** 114

**Tudor** 9, 10
Black Bay Chrono Pink **10**; 10

**Universal Genève**
Polerouter 99

**Vacherin Constantin** 20, 30, 32
Ref. 4877 20

**SONGS & ALBUMS**

'Cartier' (1990) 73
'Caught Out There' (1999) 138
'Crazy in Love' (2003) 67
'Empire State of Mind' (2009) 67
'Heartbreaker' (1999) 67
'Otis' (2011) 71
'Rude Boy' (2009) 101
'Take a Bow' (2008) 101, 103
'Umbrella' (2007) 67
*Chromakopia* (2024) 129
*Midnights* (2022) 125
*Reasonable Doubt* (1996) 67

**FILMS**

*Absence of Malice* (1981) 90
*Apocalypse Now* (1979) 20
*Arnold* (2023) 108
*Barbie* (2023) 44
*Beckham* (2023) 10
*Bedtime Story* (1964) 20
*Bend It Like Beckham* (2002) 12
*Bling Ring, The* (2013) 18
*Borderlands* (2024) 57
*Bullitt* (1968) 82
*Butch Cassidy and the Sundance Kid* (1969) 90
*Colbert Report, The* (TV show) 57
*Color of Money, The* (1986) 90
*Commando* (1985) 111
*Conan the Barbarian* (1982) 108
*Crazy Rich Asians* (2018) 150, 153
*Crouching Tiger, Hidden Dragon* (2000) 150
*Daylight* (1996) 121
*Death Race 2000* (1975) 122
*Demolition Man* (1993) 122
*Desperately Seeking Susan* (1985) 44
*Drive* (2011) 44
*Emily in Paris* (TV show) 24
*Everything Everywhere All at Once* (2022) 150
*F1* (2025) 99
*Fall Guy, The* (2024) 44
*Fall Guy, The* (TV show) 47
*Godfather, The* (1972) 20
*Hot Ones* (TV show) 10
*Indochine* (1992) 24, 27
*Iron Man* (2008) 34
*Judge Dredd* (1995) 122
*Jumanji: The Next Level* (2019) 54
*Jumanji: Welcome to the Jungle* (2017) 54
*Junior* (1994) 111
*Kindergarten Cop* (1990) 111
*Knives Out* (2019) 44
*Last Tango in Paris* (1972) 20
*Late Late Show, The* (TV show) 18
*Le Mans* (1971) 85
*Loiter Squad* (TV show) 129
*Lord of the Rings, The* trilogy (2001–2003) 17
*Moneyball* (2011) 6
*Ocean's Twelve* (2004) 97
*On the Waterfront* (1954) 20
*Once Upon a Time in Hollywood* (2019) 97
*Oppenheimer* (2023) 34
*Pirates of the Caribbean* film series (2003–2017) 17
*Predator* (1987) 108
*Queen & Slim* (2019) 101
*Rambo* franchise (1982–2019) 121
*Repulsion* (1965) 24
*Ride Along* (2014) 54
*Rocky* (1976) 121
*Running Man, The* (1987) 111
*Slap Shot* (1977) 90
*Sting, The* (1973) 90
*Terminator, The* (1984) 108, 111
*Great Escape, The* (1963) 82
*Last Metro, The* (1980) 24
*Tomorrow Show, The* (TV show) 73
*Tomorrow Never Dies* (1997) 150
*True Lies* (1994) 111
*Twins* (1988) 108
*Undeclared* (TV show) 54
*Verdict, The* (1982) 90
*Winning* (1969) 90
*Wolfs* (2024) 99

**CARS**

BMW M3 129
Ferrari 50
Fiat 131 Abarth Rally 129
Hot Wheels 129
Lancia Delta Integrale Evo II 129
McLaren 675LT 129
Mustang P-51K-10 17
Rolls-Royce Cullinan 129

# Picture Credits

**Front cover** Image courtesy of Richard Mille
**Back cover** Image courtesy of Richard Mille
**p2** Image courtesy of Audemars Piguet
**p8** UPI / Alamy Stock Photo
**p10** Image courtesy of Tudor
**p11** UPI / Alamy Stock Photo
**p12** Image © Rolex/Jean Daniel-Meyer
**p13** Vince Flores / Alamy Stock Photo
**p14** Image courtesy of Breitling
**p15** Image © Rolex
**p16** Sandy Young / Alamy Stock Photo
**p19 above** Image courtesy of Bremont
**p19 below** Image courtesy of Bremont
**p21** Collection Christophel / Alamy Stock Photo
**p22** Image courtesy of CHRISTIE'S IMAGES LTD. 2025.
**p23** WolfTracerArchive / Alamy Stock Photo
**p25** ALLSTAR PICTURE LIBRARY / Alamy Stock Photo
**p26** Image courtesy of Cartier
**p28** ALLSTAR PICTURE LIBRARY / Alamy Stock Photo
**p29** REPORTERS ASSOCIES / Gamma-Rapho / Getty Images
**p31** Tim Graham / Tim Graham Photo Library / Getty Images
**p32** Tim Graham / Tim Graham Photo Library / Getty Images
**p33** Image courtesy of Cartier
**p35** Media Punch / Alamy Stock Photo
**p36 left** Image courtesy of Jaeger-LeCoultre
**p36 right** Taylor Hill / Getty Images Entertainment / Getty Images
**p37** Image courtesy of Jaeger-LeCoultre
**p38** Nippon News / Alamy Stock Photo
**p40** Image © Rolex
**p41** Image © Rolex
**p42–43** Mark Pain / Alamy Stock Photo
**p44** Image courtesy of TAG Heuer
**p45** Jaguar / Alamy Stock Photo
**p46** Image courtesy of TAG Heuer
**p47** Image courtesy of TAG Heuer
**p48** Photography Chris Coe courtesy of IWC
**p49** Image courtesy of IWC
**p50** Image courtesy of Richard Mille
**p51** PA / Alamy Stock Photo
**p52–53** IPA / Alamy Stock Photo
**p55** Geisler-Fotopress / Alamy Stock Photo
**p56** Image courtesy of Richard Mille
**p58** Media Punch / Alamy Stock Photo
**p59** Gabe Ginsberg / FilmMagic / Getty Images
**p61** Boitano Photography / Alamy Stock Photo
**p63** Image courtesy of Patek Philippe
**p64** Image © Rolex
**p65** Image © Rolex
**p66** Craig Barritt / Getty Images Entertainment / Getty Images
**p68** Prince Williams / FilmMagic / Getty Images
**p69** Prince Williams / FilmMagic / Getty Images
**p70** Rich Kane Photography / Alamy Stock Photo
**p72** PictureLux / Alamy Stock Photo
**p73** Image courtesy of CHRISTIE'S IMAGES LTD. 2025.
**p74** Image courtesy of CHRISTIE'S IMAGES LTD. 2025.
**p75 above** Image courtesy of CHRISTIE'S IMAGES LTD. 2025.
**p75 below** Image courtesy of CHRISTIE'S IMAGES LTD. 2025.
**p77** Everett Collection / Alamy Stock Photo
**p78** Photography Mark Kauzlarich courtesy of *Hodinkee*
**p79** Timothy Norris / Getty Images Entertainment / Getty Images
**p80** Jennifer Cohen / Alamy Stock Photo
**p81** Michael Buckner / WWD / Getty Images
**p82** Image courtesy of Sotheby's
**p83** Anwar Hussein / Getty Images News / Getty Images
**p84** Image courtesy of Sotheby's
**p85** PictureLux / Alamy Stock Photo
**p86** JEAN-CHRISTOPHE BOTT / Alamy Stock Photo
**p87** Image courtesy of Jacob & Co.
**p88** Image courtesy of Jacob & Co.
**p89** Megan Briggs / Stringer / Getty Images North America / Getty Images
**p91** JT Vintage / Alamy Stock Photo
**p92** Image courtesy of Sotheby's
**p93** Image courtesy of Sotheby's
**p94** Image courtesy of Sotheby's
**p95** Douglas Kirkland / Corbis Premium Historical / Getty Images
**p96** Peter Phillips / Alamy Stock Photo
**p98** Image courtesy of IWC
**p100** Jon Kopaloff / FilmMagic / Getty Images
**p102** Image courtesy of Jacob & Co.
**p103** Image courtesy of Piaget
**p105** Eduardo Parra / WireImage / Getty Images
**p106** Image courtesy of Jacob & Co.
**p107** Image courtesy of Jacob & Co.
**p109** Anwar Hussein / Hulton Archive / Getty Images
**p110** Image courtesy of Audemars Piguet
**p112** Image courtesy of Audemars Piguet
**p113** Image courtesy of Seiko
**p115** Timothy Norris / Getty Images Entertainment / Getty Images
**p116** Image courtesy of G-Shock
**p117** Image courtesy of IWC
**p118** Image courtesy of Richard Mille
**p119** Lenscap / Alamy Stock Photo
**p120** dpa / Alamy Stock Photo
**p121** Image courtesy of Phillips
**p122** Samir Hussein / WireImage / Getty Images
**p123** Image courtesy of Richard Mille
**p124** Frazer Harrison / Getty Images Entertainment / Getty Images
**p125** Image Rhonda Riche
**p126** Image courtesy of Louis Vuitton
**p127** Image courtesy of Chopard
**p128** ZUMA Press / Alamy Stock Photo
**p130** Image courtesy of Casio
**p131 above** Image courtesy of Cartier
**p131 below** Image courtesy of Cartier
**p133** Nancy R. Schiff / Archive Photos / Getty Images
**p134** Image Rhonda Riche
**p136** Image courtesy of Piaget
**p137** Fairchild Archive / Penske Media / Getty Images
**p139** Shane Anthony Sinclair / Getty Images Entertainment / Getty Images
**p141** Image courtesy of Richard Mille
**p143** dpa / Alamy Stock Photo
**p145** Christopher Polk / Variety / Getty Images
**p146** Frazer Harrison / Getty Images Entertainment / Getty Images
**p147** Image courtesy of Audemars Piguet
**p148** Image courtesy of Audemars Piguet
**p149** Image courtesy of Audemars Piguet
**p151** Tim P. Whitby / Getty Images Entertainment / Getty Images
**p152** Image courtesy of Richard Mille
**p153** Ernest S. Ruscio / Getty Images Entertainment / Getty Images
**p154** Image courtesy of Richard Mille
**p155** Image courtesy of Patek Philippe

# Copyright

© 2025 Rhonda Riche
World copyright reserved

ISBN: 978 1 78884 339 3

The right of Rhonda Riche to be identified as author of this work has been asserted by her in accordance with the Copyright, Designs and Patents Act 1988

All rights reserved. No part of this publication may be reproduced, stored in a retrieval system, or transmitted in any form or by any means electronic, mechanical, photocopying, recording or otherwise, without the prior permission of the publisher

A CIP catalogue record for this book is available from the British Library

The author and publisher gratefully acknowledge the permission granted to reproduce the copyright material in this book. Every effort has been made to trace copyright holders and to obtain their permission for the use of copyright material. The publisher apologises for any errors or omissions in the text and would be grateful if notified of any corrections that should be incorporated in future reprints or editions of this book.

Editor: Alice Bowden
Designers: Mariona Vilarós and Steven Farrow
Reprographics manager: Corban Wilkin

**EU GPSR Authorised Representative:**
Easy Access System Europe Oü, 16879218
Address: Mustamäe tee 50, 10621 Tallinn, Estonia
Email: gpsr@easproject.com Tel: +358 40 500 3575

MIX
Paper | Supporting responsible forestry
FSC® C008047
www.fsc.org

Printed in China by C&C Offset Printing Co. Ltd
for ACC Art Books Ltd, Woodbridge, Suffolk, UK

www.accartbooks.com

ACC ART BOOKS